Cecilia Granata

"Mama tried

CIBO

TRADITIONAL
Italian Cooking FOR THE
SCREWED * CRUDE * VEGAN & TATTOOED

MAMA TRIED: Traditional Italian Cooking for the Screwed, Crude, Vegan & Tattooed

First printing, April 12, 2016

For a catalog, write
Microcosm Publishing
2752 N. Williams Ave
Portland, OR 97227
or visit MicrocosmPublishing.com

ISBN 978-1-62106-740-5
This is Microcosm #224

Distributed worldwide by Legato / Perseus and in the UK
by Turnaround

This book was printed on post-consumer paper in the
United States.

Library of Congress Cataloging-in-Publication Data is
available upon request.

Some of the recipes were inspired by
the fantastic Italian blog
www.veganblog.it
Definitely check it out, as it is an
endless source of inspiration for the
Italian herbivores.

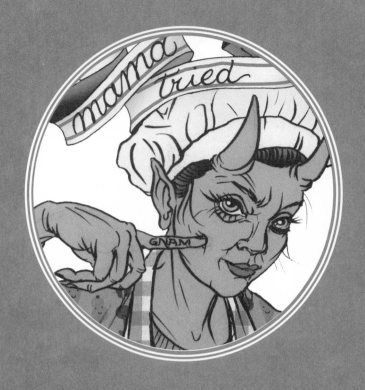

This book goes to Luca, my handsome devil.
To my Mom and Dad for the boundless support in my good choices, my much loved Nonna Marisa, and my adorable nieces. "To all my friends" and my special girls, to the voiceless animalia, to Gaia, to Italy and Pizza, to Yoga, purest form of knowledge, to the precious veggies, and to imperfect Beauty in all its forms.
With Love and Ahimsa,
Cecilia

SPREADS,
SAUCES &
CONDIMENTS

APPETIZERS

FIRST COURSE

SOY
FREE

SECOND /
MAIN COURSE

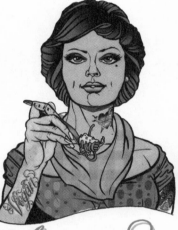
Vegan
SYMBOLS

SIDES

GLUTEN
FREE

DESSERT &
SWEET TREATS

"CHEESE" &
UN-DAIRY

QUICK
RECIPE

LIQUEUR

CONVERSION TABLE

1/2 oz	⟶	15g
3/4 oz	⟶	20g
1oz	⟶	30g
2oz	⟶	60g
3oz	⟶	85g
4oz ⟶ 1/4lb	⟶	115g
5oz	⟶	140g
6oz	⟶	170g
7oz	⟶	200g
8oz ⟶ 1/2lb	⟶	230g
12oz ⟶ 3/4lb	⟶	340g
16oz ⟶ 1lb	⟶	450g

1oz=28.35g
1g=0.035oz

°F	°C
250	120
275	140
300	150
325	170
350	180
375	190
400	200
425	220
450	230
475	240

$$°F = °C \times 1.8 + 32$$

$$°C = (°F - 32) / 1.8$$

TABLE OF CONTENTS

Pasta e Fagioli | **Pasta with Beans**..*111*
Pisarei e Faso | **"Pisarei" Pasta & Beans**..*112*
Pizza al Trancio | **Thick Pizza**..*114*
Pizza Fritta | **Fried Pizza**...*115*
Pizza Napoletana di Scarola | **Escarole Stuffed Pizza from Naples**....................*116*
Pizzata Ligure | **Flat Pizza Liguria Style**..*117*
Veg-crescenza Sauce..*118*

Q

Quadrati di Panna Cotta | **Panna Cotta Cubes with Berries & Chocolate Sauce**.................*120*

Risi E Risotti | **Rice & Risottos**

R

Risi e Bisi | **Rice & Young Peas**..*123*
Risotto ai Borlotti e Pomodoro | **Bean & Tomato Risotto**..*124*
Risotto ai Funghi | **Mushroom Risotto**...*125*
Risotto alla Birra con Radicchio e Salsiccia | **Beer Risotto with Sausage & Red Chicory**.........*126*
Risotto alla Milanese | **Saffron Risotto**...*128*
Risotto al Mascarpone e Pepe Rosa | **Risotto with "Mascarpone" Cheese & Pink Pepper**....*129*
Risotto al Salto | **Crunchy Leftover Risotto**..*130*
Risotto Gratinato alle Verdure | **Oven Broiled Rice with Veggies**.............................*131*
Risotto alle Fragole | **Strawberry Risotto**...*132*
Risotto Ubriaco | **Drunk Risotto**..*134*

Scaloppine e Spezzatini Senza Sofferenza | **Suffering-Free Scallops and Stews**

S

Scaloppine di Seitan | **Seitan Scallops in Lemon & Wine Sauce**..................................*136*
Peperoni Gialli con Uvetta e Pinoli | **Sauteed Yellow Peppers with Pine Nuts & Raisins**....*137*
Scaloppine di Seitan al Timo e Capperini | **Seitan Scallops with Capers & Thyme**........*138*
Pomodorini al Forno | **Oven Roasted Cherry Tomatoes**..*139*
Spezzatino con Patate | **Seitan Stew with Potatoes**...*141*
Spezzatino con Patate e Piselli | **Seitan Stew with Potatoes & Sweet Peas**...............*142*
Spezzatino ai Funghi Porcini | **Seitan Stew with Porcini Mushrooms**........................*144*

T U V Z

Tiramisú...*146*
Uuuuuh: La Robiola Vestita | **Uuuuh, the Vegan Robiola Cheese Dressed in Red!**.........*147*
Vin Brulé | **Hot Mulled Wine**...*148*
Zuppa Pisana | **Vegetable Soup with Bread from Tuscany**...*150*

Vegan Cheese

C H E E S E & U N D A I R Y

Veg-Mozzarella...*152*
Panna di Soia | **Soy Cream**...*153*
Veg-Ricotta | **Vegan Ricotta Cheese**..*154*
Veg-Caprino | **Vegan Goat Cheese**...*155*
Veg-Ricotta Salata | **Vegan Salted Ricotta Cheese**..*156*

INTRODUCTION

A glorious triad of manias—art, food, and the alphabet—inspired this book. Mama Tried is as much cookbook as it is a tattoo flash collection. Being a tattoo artist, I see a connection between vegan recipes and the fresh-edgy-pop look of this art form, that makes things light with a fun twist and takes away some of the heaviness often associated with veganism.

Let's get into some practical information about how to navigate this tasty mess. (Quirky note: the Italian word for "pastry" is pasticcino, which translates to "little mess." How cute and appropriate is that??!)

Mama Tried comprises over 100 recipes from the various traditions of the different regions of Italy. In these pages, you will find appetizers, first and main courses, condiments, liqueurs, desserts, non-dairy dairy products and an entire chapter dedicated to aphrodisiac recipes.

Each chapter corresponds to one letter of the Italian alphabet; all the recipes within that section begin with that same letter (in Italian, but luckily you also get an English translation), which means there are all kinds of recipes in a chapter. To make things a bit easier, you'll find a convenient symbol next to each recipe title, telling you if you are about to eat soup or dessert, or if the recipe is quick to make, gluten-free, or soy-free. The first chapter, A as in Appetizers (antipasti), is an exception and contains one appetizer for each letter of the alphabet.

Some of the recipes are vegan by default. Others have been veganized in order to introduce you to a wide range of typical flavors of Italy in their cruelty-free versions. Italy has an extraordinary variety of food and infinite ways of presenting and consuming it. Each area adds something different and its cuisine reflects the availability of local ingredients. In this sense, Italian food maintains to this day a close relationship to the Earth and its cycles. I aim to provide hints of this fabulous puzzle and invite you to always work with your own local products and find the variations that fit each season and the territory. This is not only to maintain the peculiarity of Italian style, but also to value a sustainable lifestyle in which we can cooperate with this planet in a functional way. Food is the most direct relationship we have with our own role in the world. As fun and pleasurable it can be, let's never forget its intrinsic radical power.

Here is another very Italian note: many of the recipes call for your own judgment. You will be asked to adjust quantities and even some ingredients depending on your taste and on what you have left in the fridge. A lot of food publications in Italy would ask you to eyeball the amounts; it's not uncommon to find recipes even without amounts at all! People are generally more used to home-cooking and pretty much all Italians are preparing their own food most of the time. You will not be asked to make up the instructions, but don't be surprised if I ask you to use your intuition to finish making your dinner.

On the last notes of this Italian stream of consciousness, please be advised that you'll also find some foreign terms. Let me introduce you the most recurrent and un-avoidable: the fabulous "soffritto". This is the very base of a lot of recipes. It simply means to sauté sliced garlic or onions (depending on what the recipe calls for....some fancier variations include thin-sliced carrots and celery, parsley or other spices) in a thread of extra virgin olive oil until they get translucent without burning. To this, you will add all kinds of marvelous things and start building the recipe.

Most importantly, about the garlic: any time I mention this flavorsome ingredient, please note I mean the clove cut in half, without the skin and without the green germ, which in Italian is romantically called anima, or soul. So skin that motherfucker to its very essence and indulge in the only moment of cruelty you are allowed within this publication.

There is something magical, alchemical, so vibrant and passionate about food preparation. I have always loved spending time in the kitchen with mom and grandma, learning secrets infused with love, embracing the desire to please and nurture, playing the witch who stirs potions out of herbs, bringing people together in convivial sympathy around a table. What you'll find here is this, a genuine passion and curiosity for cooking, feeding and eating in a way that is un-pretentious, fun, casual and sometimes messy but never bloody.

This is my first book. I hope that you and all the other animals in the world will enjoy it.

ARANCINI DI RISO
SICILIAN RICE BALLS

 yields four arancini

- INGREDIENTS -
1 1/2 cups arborio rice/risotto rice
6 1/4 cups vegetable broth
1 large pinch saffron
3 full tbsp margarine
8 small pieces of veg-mozzarella **(recipe on page 152)**
Breadcrumbs as needed

For the sauce:
4 cups of vegetable broth
1 carrot
1 onion
2 stalks of celery
1 small can of tomato paste
1/3 cup white wine
2/3 cup soy milk
1/2 cube vegetable bouillon
5 oz vegan ground beef
Extra virgin olive oil
Black pepper to taste

The vegan ground beef can be substituted with ground seitan or soy protein.

1 Boil the rice in 4 full cups of broth. When it is absorbed completely, add the rest of it with the saffron melted in and continue cooking until all the water is absorbed, adding more water if needed until the rice is ready.

2 Add the margarine, stir well, and set it aside to let cool.

3 Make a soffritto by frying the carrot, onion and celery in olive oil. Add the green peas and the bouillon. Add the vegan ground beef, stirring often, and cook for ten minutes. Add the wine and cook for ten more minutes.

4 Add some hot water to the tomato paste and toss it in the pan. Mix well, cover with a lid, lower the heat and cook for about thirty minutes. Add the soy milk, pepper to taste and cook until the mixture gets quite thick (about twenty minutes). When it's ready, let it cool.

5 Make the arancini by wetting your hands and grabbing a handful of rice. Dig a hole in the middle and fill it with 1 tbsp of sauce and two pieces of veg-mozzarella. Close the arancino with more rice, forming a ball.

6 Mix a thick batter from flour and water, toss each ball in it, and roll it in breadcrumbs. Repeat this step twice to make them more solid.

7 Give the arancini a "pyramidal" shape and deep fry in frying oil. Put them on a plate with a paper towel to absorb the extra oil. Eat hot!

BRUSCHETTE ALLE CIME DI RAPA
BROCCOLI RABE BRUSCHETTA

 yields four bruschette

- INGREDIENTS -
4 big slices of Italian bread (the big and round kind of bread)
2 peeled garlic cloves
2 1/3 cups broccoli rabe
2 tbsp extra virgin olive oil plus more to garnish
Salt to taste
Dried hot chili pepper to taste

1 Rinse the broccoli rabe and cut it in pieces. Put 1 garlic clove in a pan with 2 tbsp oil and toss the broccoli rabe in. Sauté for few minutes. Add a pinch of salt with a few tablespoons of water, cover, and cook for fifteen minutes. If the water gets absorbed before the broccoli is soft, add some more. Adjust with salt to taste.

2 Meanwhile, place the bread slices in the oven on broil until crunchy. Remove from the oven and rub a garlic clove on the surface of each slice.

3 When the broccoli is ready, place on the bread and add a little oil with hot chili pepper (see page 105). Enjoy!

CIPOLLINE IN AGRODOLCE
SWEET & SOUR ONIONS

- INGREDIENTS -
15 oz peeled cippolini onions
2 tbsp margarine
1/3 cup red wine vinegar
2 tbsp sugar
2 bay leaves

1 Place the onions in a bowl filled with cold water for about thirty minutes.

2 Melt the butter and the sugar in a casserole, add the vinegar and cook for one minute. Add the onions and the bay leaves and cook covered, on low heat for about forty minutes, or until they are soft. If necessary, add more hot water.

DELIZIE DEL DIAVOLO
DEVIL'S DELIGHT—CRUNCHY BREAD RINGS

usually called "taralli"

- INGREDIENTS -
4 full cups unbleached flour
1/2 cup dry white wine
1 1/2 tsp sea salt
1/2 cup extra virgin olive oil
1 tsp crushed and dry hot pepper

1 *Pour the flour in a bowl with the wine, oil, salt and hot pepper. Roll well with your hands until you get a smooth and compact dough. Cover it with a kitchen towel.*

2 *Meanwhile, bring a pot of slightly salted water to boil. Turn the oven on to 400°F.*

3 *Roll the dough into sticks, sized similarly to a finger. Dampen your hands and shape each one to make a ring, pressing one end to the other with a wet finger to make them stick together. Boil them until they rise to the surface. Delicately drain and dry for few minutes on a kitchen towel.*

4 *Place on a baking tray and bake for twenty minutes, until golden. Serve with sun-dried tomatoes, black olives, and veg-caprino* **(see page 155).**

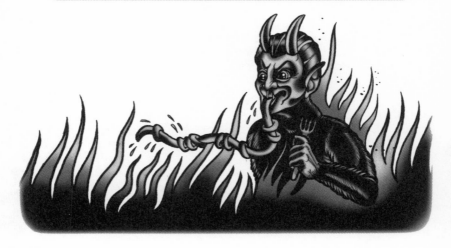

EDAMAME ALL'ITALIANA
ITALIAN STYLE EDAMAME

- INGREDIENTS -
1 small yellow onion
2 cups cherry tomatoes cut in half
Sea salt to taste
5 oz edamame
Extra virgin olive oil as needed
A pinch of oregano
A pinch of thyme

1 *Boil the edamame al dente. Make a soffritto by frying the onion in the olive oil until it becomes golden without burning.*

2 *Add the edamame, tomatoes, salt, and spices. Cook covered on low heat until the edamame is ready. Add a little oil if it becomes too dry.*

Serve with other vegetable antipasti and toasted bread.

FIORI DI ZUCCA FRITTI
FRIED ZUCCHINI FLOWERS

make enough batter to suit the flowers you plan to prepare—4 cups make about 20 flowers.

- INGREDIENTS -
Zucchini flowers
Batter made with flour, water, and a pinch of salt
Frying oil

1 Gently wash the flowers with water. Remove the stems and pat dry on a towel.

2 Dip the flowers in the batter and immediately deep fry them. Remove from the pan and place on a dish with paper towels to drain the extra oil.

Serve immediately.

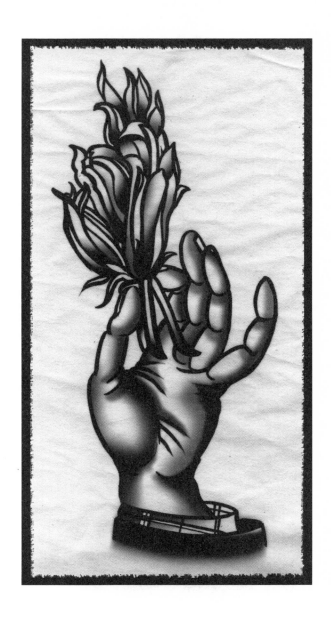

GNOCCO FRITTO
FRIED DOUGH

- INGREDIENTS -
4 cups flour
2 tbsp margarine
1 tbsp extra virgin olive oil
2 pinches of salt
1 pinch of baking soda
1+1/4 cup water mixed with unsweetened plain soy milk
frying oil as needed

1 Combine the water and soy milk, adding a little more soy milk, and warm it. Sift the flour on a flat surface, making a mountain. Dig a hole on the top and pour the semi-melted margarine, the water and milk mixture, baking soda, and salt to taste.

2 Knead the dough until firm and smooth. Let it rest, covered, for thirty minutes. With a rolling pin, roll the dough thin. Cut it into 2 x 5 inch rectangles.

3 Toss a few pieces at a time into hot frying oil and fry until they become puffy and golden.

Serve hot with different kinds of vegan cheese and Field Roast deli slices or anything on that note.

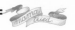

HAMBURGERINI DI CAVOLFIORE
CAULIFLOWER MINI BURGERS

- INGREDIENTS -
1 cup boiled lentils (canned lentils are okay, too)
1 cup cauliflower
1 small peeled potato
1 yellow onion cut into thin slices
2 or 3 tbsp breadcrumbs, as needed
Olive oil as needed
Sea salt to taste

1 Steam the cauliflower and potato until soft, cut into small pieces, and smash. Mix the cauliflower, potato, onion, lentils, salt and breadcrumbs together in a big bowl with your hands until it gets thick enough to make balls. Add breadcrumbs and a little oil if needed.

2 Place in a baking dish with baking paper. Press the balls into small patties and bake for fifteen minutes at 350°F.

3 After this step, you can either fry them in a pan with a little olive oil until the crust is golden, or serve right out of the oven.

INSALATA DI PATATE E FAGIOLINI
POTATO & STRING BEAN SALAD

for four to five people

- INGREDIENTS -
3 big peeled potatoes, cut into big dices
String beans, as much weight as the potatoes
Sea Salt
2 tbsp of extra virgin olive oil, or more to taste
2 tbsp of pesto, or more to taste **(recipe on page 107)**

1 Steam the potatoes with sea salt until soft but firm. Boil the string beans in salted water until soft. Mix the potatoes and string beans together in a bowl.

2 Add a little extra virgin olive oil and stir. Serve in small bowls with a spoonful of pesto on top.

LUNETTE RIPIENE DI VERDE E NERO
GREEN & BLACK STUFFED BREAD POCKETS

makes four lunettes

- INGREDIENTS -
3 1/3 cups white flour
1 1/2 tbsp baking powder
4 tbsp extra virgin olive oil
Sea salt to taste
Water as needed

For the filling:
2 zucchini, sliced in thin circles
4 or 5 green asparagus, cut in small pieces
1 cup green peas (or canned green peas)
1 peeled garlic clove
Leaves of fresh basil
Black olives (preferably niçoise), pitted and cut into pieces
1 small yellow onion, thinly slicedly
White ground pepper, to taste
Olive oil

1 Make a soffritto by sautéing garlic and onion in the oil with a pinch of salt on low heat until soft. Steam the asparagus and green peas with salt until soft. Add the zucchini and cook with a lid until they are soft. Add the asparagus, sweet peas, basil, and olives.

2 Cook, covered, for few more minutes. Add a pinch of white pepper and a little salt if needed. Uncover and cook on high heat to make the vegetables golden. Set aside.

3 Mix all the ingredients for the dough and knead with your hands until it gets smooth and tight. Roll with a rolling pin, making it one-fourth of an inch thick.

4 Cut four circles out of the dough. Pour spoonfuls of the filling on one half of each circle. Fold in half to make half moons, pressing the sides together firmly with wet fingers.

5 Deep fry the lunettes until golden. Absorb the extra oil with paper towels and serve hot.

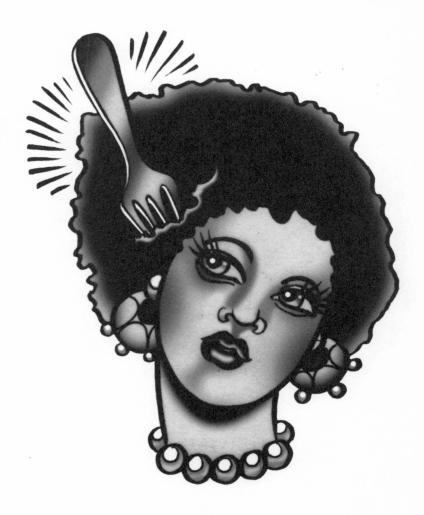

MELANZANE GRIGLIATE AL FORNO
OVEN GRILLED EGGPLANTS

- INGREDIENTS -
2 or 3 big eggplants
A few pinches of sea salt
Extra virgin olive oil
2 cloves of minced garlic
Dried oregano to garnish
Breadcrumbs to garnish

It really makes a difference if you can find good quality oregano imported from southern Italy!

1 Slice the eggplants in half-inch thick slices. Place on a big plate, sprinkle with a few pinches of salt, and cover with a pile of dishes or something heavy to squeeze the water out. Press and drain for thirty minutes. After they are dry, pat each slice with a kitchen towel.

2 Grease the bottom of a baking pan with oil. Place the eggplant slices in one layer and cover with garlic, oregano, salt, and breadcrumbs. Pour threads of extra virgin olive oil over the eggplant slices. Put in the oven on 280°F for twenty to thirty minutes or until soft, then broil for few minutes.

Eat with bread and other appetizers.

NIDINI DI PATATE E BROCCOLI
POTATO & BROCCOLI NEST

- INGREDIENTS -
3 big potatoes, peeled and cut in small chunks
2 1/2 cups broccoli
Sea salt to taste
A pinch of ground black pepper
2 tbsp breadcrumbs
Margarine

1 Bring a deep pot of salted water to a boil. Add the potatoes and cook for eight minutes. Add the broccoli until both the potatoes and broccoli are very soft.

2 Drain, place in a bowl, and smash with a fork. Add a pinch of black pepper, salt if needed, 2 tbsp breadcrumbs, and 1 tbsp margarine. Mix well.

3 Grease a muffin dish with margarine. Fill the muffin molds with the potatoes/broccoli mix. Add a few flakes of margarine on top of each shape and broil until golden. Let cool a few minutes and serve.

Serve with a small green salad on the side or some vegan mayo.

ORZO MONDO!! ORZO E ORTICA IN POLPETTE
BARLEY & NETTLE BALLS

- INGREDIENTS -
4 cups cooked barley
2 1/2 cups nettle
1 tbsp tahini
2 tbsp extra virgin
olive oil, sea salt, and
pepper to taste

EAT YOUR GREENS

1 Wash the nettle (be careful! use gloves!) and boil it for about fifteen minutes in unsalted water. Drain very well.

2 Blend the nettle with the rest of the ingredients in a blender until you get a chunky paste. If you want to make it creamier, add a little water. If you want it thicker, add breadcrumbs.

3 Warm up 1 tbsp of olive oil in a pan. Make ping pong sized balls with the mix and roast them until they are golden.

Serve hot with grissini
(recipe on page 62) or
warm bread.

PANELLE PALERMITANE
CHICKPEA FLOUR FRITTERS

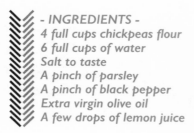

- INGREDIENTS -
4 full cups chickpeas flour
6 full cups of water
Salt to taste
A pinch of parsley
A pinch of black pepper
Extra virgin olive oil
A few drops of lemon juice

Panelle are a typical Sicilian street food. They are quite thin and are eaten on a bun with lemon and salt. For a variation from Liguria, see Panissa on page 33.

1 Toss the flour in a big pot. Add the cold water slowly while stirring, avoiding crumbs. When all the water is added and your batter is smooth, cook on low heat. After a few minutes, add the salt and stir well to prevent the batter from sticking to the bottom of the pot. Stir for thirty to forty minutes. (Find someone to talk to, that will help you keep stirring.)

2 You'll notice when the batter is ready because it will start detaching from the pot. Add parsley and pepper and stir well. Pour the batter in a greased loaf pan. Let it cool.

3 Lift it from the loaf pan when it has cooled off and put it on the table. Start cutting it with a wet knife into half-inch slices. Deep fry each panelle until they are gold. Squeeze a few drops of lemon juice on the hot panelle right before eating, add salt, and serve on burger buns.

QUADRATI DI TOFU IN SPIEDINO
TOFU SQUARE SKEWERS

- INGREDIENTS -
6 oz extra firm sprouted tofu
Soy sauce
1 branch fresh rosemary
Ground sage
1 clove garlic, no skin no soul
Cherry tomatoes
1 zucchini
Black olives without the pit
1 yellow pepper
Extra virgin olive oil

1 Cut the tofu into big dices and marinate it with soy sauce, rosemary, sage, and garlic for about 1 hour in the refrigerator.

2 Slice the zucchini into thin strips, cut the pepper in small squares and the cherry tomatoes in half. Heat a grilling pan and grill the 3 veggies with a bit of salt until they get a brown, striped surface. Do the same with the tofu after marinating.

3 Place the tofu, pepper, zucchini, cherry tomato and olives on wood skewers, alternating them. Heat in the oven on low temperature (about 250°F) with a thin thread of extra virgin olive oil until they are warm.

ROTOLINI DI PEPERONI
STUFFED PEPPER ROLLS

- INGREDIENTS -
1 yellow bell pepper
1 red bell pepper
1 cup cooked green peas
Sesame seeds
*1 cup veg-ricotta **(recipe on page 154)***
Fresh parsley to taste
3 branches of fresh thyme OR 5-10 basil leaves to taste
Extra virgin olive oil as needed
Sea salt to taste

1 *Heat the oven to 390°F. Wash the peppers and cut into large slices, removing the seeds and white parts. Lightly sprinkle them with salt and place them right on the oven rack.*

2 *Bake until soft and flip them so that the skin side is on the top. Broil on high until they are golden. Remove from the oven and let cool a little bit.*

3 *Meanwhile, mix the ricotta, peas, parsley, and thyme or basil with a fork. Add sesame seeds and salt to taste. Place the mixture on the pepper strips and roll them up (hold them in place with a toothpick if they open up). Drizzle with a thread of extra virgin olive oil and serve.*

SFILATINO SFIZIOSO
TOMATO & OLIVE BREAD ROLL

- INGREDIENTS -
Pizza dough **(recipe on page 114)**
1 cup cherry tomatoes, cut in half and salted
1 cup of pitted olives
Extra virgin olive oil to grease the pan

1 Preheat your oven to 450°F. Add olives and tomatoes to the dough, folding them in with your hands. Roll the dough into strips that are seven inches long and one inch thick.

2 Grease the strips with a little bit of oil and place on an oiled baking tray. Bake for twenty to twenty-five minutes or until they have a golden crust. Be sure to check on them because they might be ready earlier if they are smaller.

TORTINE DI VERDURA
SMALL VEGETABLE PIES

- INGREDIENTS -
For the crust:
3 1/3 cups manitoba flour (white or whole wheat flour works)
2/3 cup sunflower oil
1/2 tsp sea salt
1/2 cup dry white wine

For the filling:
3/4 cup veg-ricotta **(recipe on page 154)**
2 branches of fresh thyme, or to taste
2 tbsp of good quality dry oregano
2 zucchini, thinly sliced
2 small carrots, thinly sliced
1 leaf of arugula for each pie, to garnish
Cherry tomatoes, halved, to garnish

1 Preheat your oven to 360°F. Whisk the oil and wine vigorously with a fork. Make a mountain with flour and salt on a working surface. Dig a hole on the top and slowly add the oil and wine, whisking with a fork, trying not to break the mountain.

2 Knead the dough well with your hands and make a ball. Flatten it with a rolling pin so that it is one-fourth of an inch thick, cut into circles, and place in small rounded pie dishes (four inches wide).

3 Bake for ten minutes. They should become solid, but be careful not to overcook them as they harden up a bit when they cool off.

4 Mix the ricotta, salt and herbs together with a fork. Salt the zucchini, carrots, and tomatoes, and roast them in the oven until soft (maybe sprinkle the carrots and zucchini with a bit of water). When soft, add a thread of olive oil and put on broil until they make a golden crust.

5 Place the ricotta in the pies; add the zucchini and carrots, alternating them over the ricotta; add a piece of arugula, and two or three pieces of tomato on top.

UuuUUUUuuuH, LA PANISSA!
PANISSA CHICKPEA FRITTERS

- INGREDIENTS -
Chickpea flour
Water
Salt to taste
Ground black pepper to taste
Scallion (optional)
Lemon juice (optional)
Extra virgin olive oil OR frying oil

Panissa is the Ligurean version of Panelle (page 28). Panissa is served in thick slices or cubes, usually by itself or as part of a salad.

(Proportion of flour to water: about 1 to 3)

1 Heat salted water in a big pot. Once it is warmed up, pour in the flour. Cook on medium/low heat for forty minutes while stirring.

2 Pour in an oiled loaf pan and let cool. Cut into one inch thick slices.

You can choose to serve it warm with extra virgin olive oil, black pepper, lemon juice, and thinly sliced scallion OR deep fry it and serve hot with ground black pepper.

VAFFANCULO MONDO CREMA DI PEPERONCINO
FTW HOT PEPPER PASTE

- INGREDIENTS -
4 cloves peeled garlic
1 cup extra virgin olive oil
10 oz fresh red chili peppers

1 Wash the peppers and remove the stems. Toss them in a blender with garlic and salt until it forms a thick paste. Pour through a fine mesh strainer and let it drain overnight.

2 Place in a big bowl and stir in the oil until you get a creamy consistency. Serve with toasted bread or any way you like.

Remember to avoid touching your eyes and mouth. Wash your hands immediately after you are done. If the peppers are extremely hot you might want to use a pair of rubber gloves.

ZONZELLE
FRIED DOUGH

fried dough again, but in a different shape

- INGREDIENTS -
6 cups white flour
2 cubes fresh yeast
2 cups warm water
2 tbsp sea salt
1 tsp sugar
Frying oil

1 Mix the flour, salt, and sugar in a big bowl. Melt the yeast in warm water and add to the dry ingredients. Knead well until you get a smooth ball.

2 Flatten the dough and cut it into two inches pieces. When all the dough is cut, deep fry the zonzelle for few minutes until gold and puffy. Sprinkle with salt and serve hot.

BACI DI DAMA LADY'S KISSES
CHOCOLATE-HAZELNUT COOKIES

- INGREDIENTS -
1 cup white flour
3/4 cup margarine
1/2 cup sugar
1 2/3 cup hazelnut meal
Plain unsweetened soy milk as needed
Dark chocolate as needed

For a variation, use half almond meal and half hazelnut meal.

1 Preheat your oven to 350°F. Mix the hazelnut meal, flour, sugar and margarine in a bowl with your hands until you get a homogenous paste. Add a little soy milk if needed.

2 Form balls with the dough, slightly smaller then a ping pong ball, and place on an oven tray covered with parchment paper. Press the balls lightly to make one side almost flat. Bake until they become golden (twenty minutes). Let them cool.

3 Melt the dark chocolate with a little soy milk to make a creamy consistency and spread it on the flat side of a ball. Stick another ball to it. Repeat for all the Baci, let the chocolate harden, and serve.

CROCCHETTE DI PATATE
POTATO CROQUETTES

- INGREDIENTS -
3 big potatoes, peeled
A sprinkle of nutmeg
Black pepper to taste, optional
A generous sprinkle of nutritional yeast
Salt to taste
Vegan mozzarella, cut in pieces **(recipe on page 152)**
Frying oil as needed
Enough breadcrumbs to coat each crocchette twice
A large bowl of semi-liquid batter made with water and flour

1 Boil the potatoes in salted water or steam with salt until very soft. Drain and refrigerate for few hours. Mash them with salt, black pepper (optional), and nutmeg. Sprinkle in nutritional yeast and mix well with your hands.

2 Put a spoonful of the mixture in your hand, making a disc. Add a piece of mozzarella in the middle and roll to make a small cylinder. Repeat for each croquette.

3 Make a thick batter with flour and water. Dip each croquette in, then roll it in breadcrumbs. Repeat this step twice for all the croquettes.

4 Deep fry them and absorb the extra oil with paper towels. Serve hot.

CAPONATA SICILIANA
SICILIAN VEGETABLE STEW

- INGREDIENTS -
2 big eggplants
1 red bell pepper
1 yellow bell pepper
17 oz canned peeled tomatoes
1/2 yellow onion, sliced
1 garlic clove, remove skin and soul
3 celery stalks
1/4 cup vinegar plus a little bit more
3 tsp sugar
30 black and green olives, or to taste
20 leaves of fresh basil, or to taste
2 tbsp of capers
3 tbsp of pine nuts
Extra virgin olive oil as needed
Salt to taste

1 Cut the eggplants in squares and boil for a couple minutes in salted water. Drain and place them on a kitchen towel until all the water is absorbed.

2 Stir-fry the eggplant in extra virgin olive oil until golden. Absorb the extra oil with paper towels. Cut the peppers in small squares, salt them, and stir-fry them in extra virgin olive oil. Absorb the extra oil on paper towels.

3 In a big pan, sauté the onion, garlic and extra virgin olive oil. Add fresh basil and the canned tomatoes. Cook on medium/low heat for twenty minutes.

4 Meanwhile cut the celery into small pieces and cook in a small pan with water for four to five minutes. Add the olives, capers, pine nuts and a tiny bit of vinegar. Cook for ten minutes.

5 Add all of this to the tomato sauce. Mix the remaining vinegar with the sugar, add it to the caponata, salt to taste, and cook for a couple more minutes. Serve either cold or warm.

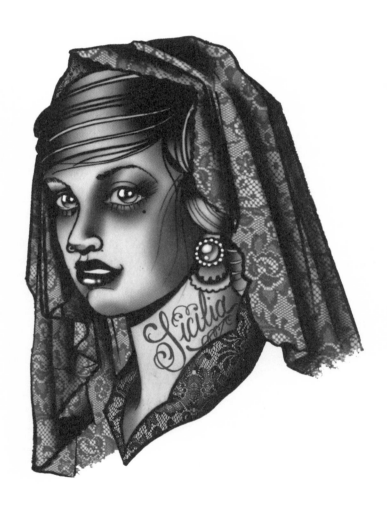

CROSTATA DI FRUTTA FRESCA
FRESH FRUIT TART

- INGREDIENTS -
For the crust:
2 1/3 cups white flour
1 cup margarine
1 cup agave syrup, or less if you don't like it as sweet
Zest of 1 washed lemon
A pinch of salt

For the cream:
2 1/2 cups soy milk
1/4 cup unbleached white flour
1 tbsp cornstarch
1 full tbsp margarine
1/4 cup sugar
1/2 tsp turmeric
Zest of 1 lemon

For the gelatin:
1 tsp agar agar flakes
3/4 cup water

To garnish:
Fresh, sliced seasonal fruits, like grapes, kiwi, bananas, berries

1 Preheat your oven to 350°F. Mix the dough ingredients and knead well with your hands to make a smooth ball. Add soy milk or water if needed. Wrap in plastic wrap and refrigerate for thirty minutes.

2 Meanwhile, prepare the cream in a big bowl by stirring the flour, corn starch and turmeric together with 1/2 cup soy milk. Mix well to avoid clumps. Cook the remaining milk with the margarine on low heat and add the lemon zest and sugar. Mix well until it is near boiling. Add the previous mixture and whisk well with a beater. Cook for three minutes, pour in a bowl, and let cool while covering it with plastic wrap (the plastic wrap should touch the surface).

3 Flatten the crust in an oven pie dish (a fourth of an inch thick). Poke the bottom with the tip of a fork to make small surface holes. Cover with foil and dry beans (this keeps the crust low) and bake for thirty minutes. Let cool and remove the beans and paper. Pour the cream over it and decorate with the fruits.

4 Make the gelatin: melt the agar agar in cold water, bring to a boil for five minutes, let it cool a little bit, and brush the fruits with it. Refrigerate for thirty minutes and serve.

How to make a fancy decoration with caramel:

Heat 1/2 cup of sugar in a nonstick pan on medium heat while stirring with a wooden spoon.

1 When it starts to thicken, lower the heat and keep stirring. After few minutes, the sugar will start to brown. Lower to minimum heat and keep stirring for few minutes.

2 On low heat, stir in just a few drops of lemon juice. When the caramel becomes an amber color, remove from heat, dip a teaspoon in and drop in fast circles to make threads over the pie.

Let solidify and serve.

MENU 2:

CROSTINI DI PANE CON CREMINA DI ZUCCHINE
CARPACCIO DI SEITAN CON VERDURE CRUDE
CESTINI DI CIOCCOLATO

CROSTINI DI PANE CON CREMA DI ZUCCHINE
BREAD CROUTONS with ZUCCHINI SPREAD

 for four people

- INGREDIENTS -
4 large or 8 small round slices of toasted bread
7 oz firm or silk tofu
1 tsp saffron
3 tbsp extra virgin olive oil
3 big zucchini
12 fresh basil leaves
sea salt and pepper to taste
1 yellow onion
1/2 lemon

1 Thinly slice the onion and sauté with olive oil and saffron (or curry) in a pan. Sliced the zucchini in thin circles and add to the pan with salt and pepper. Cook on low heat for fifteen minutes.

2 Turn off the heat, add the basil, and let cool. Crush the tofu and mix in a blender with the zucchini and onion. Save one slice of zucchini for decoration for each bread piece. Spread on the bread slices and put the zucchini slice on the top.

CARPACCIO DI SEITAN CON VERDURE CRUDE
GROUND SEITAN with FRESH VEGGIES

- INGREDIENTS -
2 oz of seitan per person
1 peeled garlic clove, thinly sliced
unsalted capers to garnish
1 OR 2 tbsp lemon juice per portion, to taste
1/3 cup soy sauce per portion
Salad (whatever you can find in your garden or local market)
Extra virgin olive oil to taste for dressing
Vegan mayo as needed

1 Grind the seitan in a blender, making it similar to hamburger meat.

2 Mix the garlic, unsalted capers, soy sauce, and lemon juice in a bowl. Add the seitan, mix well, and refrigerate.

3 Prepare your salad and dress it with extra virgin olive oil and salt or soy sauce.

Place the seitan on plates, flatten it with a fork, add 1 tsp of vegan mayo on top, decorate with few capers, and serve with salad and bread or rice cakes.

CESTINI DI CIOCCOLATO
CHOCOLATE MINI BASKETS

- INGREDIENTS -
1/2 cup dark chocolate chips
1 tbsp plain soy milk
Enough fresh berries to fill each mini basket
Enough fresh or grated coconut to fill each mini basket
Mini cupcake liners

1 Bring some water to a boil in a double boiler. Put the chocolate in a small pot above it and let it melt with the soy milk until liquid. Pour a thin layer into cupcake liners.

2 When the chocolate has solidified, pour in a second thin layer and refrigerate. Then remove the paper cups (be careful as the chocolate melts easily just from the heat of your hands) and freeze the chocolates.

To serve, remove from the freezer and fill with sliced berries and coconut.

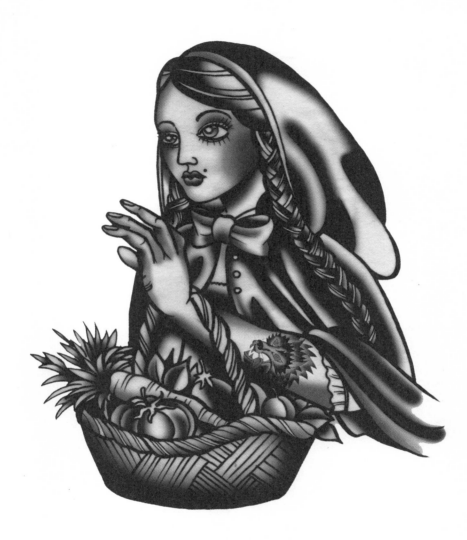

CESTINI DI VERDURE
VEGETABLE MINI BASKETS

- INGREDIENTS -
2 cups flour
2 tbsp extra virgin olive oil (plus enough to grease the dishes)
I garlic clove
I onion, thinly sliced
A pinch of sea salt for the dough (plus more for the vegetables)
I tbsp of herbs (plus more to taste for the vegetables)
Enough vegetables to fill each basket (whatever you have...
fennels and olives make a good combo)

1 Preheat your oven to 350°F. Make the dough with flour, salt, water and herbs. Roll it very thin and place it in small, greased pie dishes (about five inches wide). Bake for fifteen minutes.

2 Meanwhile cook your veggies: steam them to make them soft (if you do fennel, add the olives later). Add sea salt and herbs to taste. Make a soffritto with the olive oil, onion, and garlic. When it becomes gold, toss in the steamed veggies and let cook for few minutes with more herbs. Fill the baskets and serve.

An alternative for the filling is tofu cream cheese and sun-dried tomatoes. Or pretty much anything you can think of...use your imagination!

CONCHIGLIE MASCARPONE E ZAFFERANO
SHELL PASTA with MASCARPONE & SAFFRON

 for three people

- INGREDIENTS -
10 oz shell pasta
Sea salt
1 container tofu cream cheese
1 large pinch saffron
Nutritional yeast

1 Bring a pot of salted water to a boil and toss in the pasta. Cook al dente. Meanwhile, blend the cream cheese with the saffron until it gets strongly yellow.

2 Drain the pasta well when it is ready and mix with the cream cheese. Sprinkle with nutritional yeast.

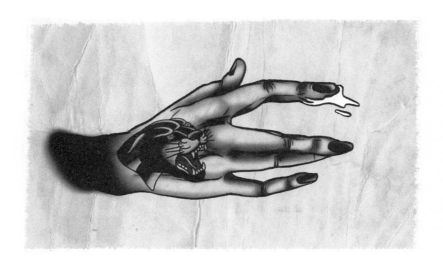

COPPA CREMOSA
CREAMY CUP

- INGREDIENTS -
Enough crumbled graham crackers for the base of each cup
Enough whole hazelnuts for a surface layer on each cup

For the cream:
2 1/2 cups vanilla soy milk
2 tbsp white flour
1 tbsp cornstarch
3/4 cup sugar
2 full tbsp margarine
1/2 tsp turmeric
Zest of 1 lemon

1 Mix 1/2 cup soy milk, turmeric, flour, and cornstarch until smooth. In a small pot, melt the margarine in 3/4 cup soy milk. Stir well and add the lemon zest, the sugar, and, finally, the rest of the soy milk.

2 Bring the second mixture to a boil while stirring, then add the first mixture. Cook for three minutes. If your cream is not smooth, let it cool and mix it in a blender. Let it cool and cover with plastic wrap (the plastic should touch the cream).

3 Drop some graham crumbles in a cup and add some cream. Repeat the layers and decorate with whole and crushed hazelnuts.

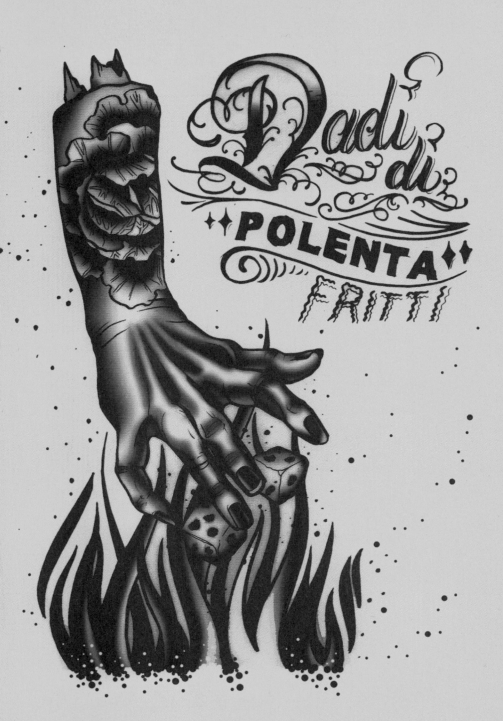

DADI DI POLENTA FRITTI
CON SUGO DI FUNGHI E VERZA ARROSTO
FRIED POLENTA DICES with MUSHROOM SAUCE & ROASTED SAVOY CABBAGE

- INGREDIENTS -

For the polenta dices:
Cooked polenta
Water
Salt
Frying oil
Black pepper

For the roasted cabbage:
2 garlic cloves
Olive oil
Soy sauce to taste
1 savoy cabbage
Black ground pepper

For the mushroom sauce:
Canned tomato sauce (plain)
Salt to taste
1 small, small pinch sugar
1 garlic clove
1 small onion, thinly sliced
1 oz dried mushrooms
Olive oil

Also delicious with purple cabbage.

1 Follow the instructions on your polenta box, then refrigerate for one night. Soak the mushrooms in hot water for thirty minutes before you start cooking. Cut the polenta in dices and deep fry in oil until the outside is golden. Salt and pepper to taste.

2 Remove the external leaves and the thick base from the cabbage, wash, and cut into slices. Boil in unsalted water for five to ten minutes until it is soft but still solid. Drain well. Heat oil in a pan with the garlic, add the cabbage and cook for few minutes on medium/high heat. Add a few tbsp of soy sauce to taste. Mix well until it is absorbed. Add the black pepper and mix. Keep covered and serve warm with the fried polenta and the mushroom sauce.

3 Heat olive oil in a pan with onion and a pinch of salt until it becomes translucent. Add the mushrooms and cook on low heat for few minutes. Add the canned tomato sauce, sugar, and salt to taste. Cook for ten minutes, stirring the whole time.

As a lighter alternative, just serve the cooked polenta sliced thick (in this case do not refrigerate overnight). Serve warm with the sauce and cabbage.

ASPARAGI AFRODISCIACI
APHRODISIAC ASPARAGUS

- INGREDIENTS -
1/3 cup breadcrumbs
1 bunch asparagus (15 to 20 stalks)
2/3 cup sour cream
3 tbsp extra virgin olive oil
paprika to taste
salt to taste

1 Wash the asparagus and cut the hard end off. Boil in salted water until al dente and drain. Drop 1 tbsp oil in an oven casserole and the rest over the asparagus, mixing them.

2 Meanwhile, toast the breadcrumbs in a pan with 1 tbsp oil. Pour the sour cream in the casserole dish, place the asparagus over it, cover with breadcrumbs, sprinkle with paprika, and broil for about 10 minutes or until they make a golden crust.

BISCOTTI AL CARDAMOMO
CARDAMOM COOKIES

- INGREDIENTS -
1 cup barley flour (or kamut or whole wheat)
2 tbsp rice flour
2 tbsp brown sugar
1 1/2 tbsp rice malt
1 tsp baking soda
3 tbsp cardamom seeds
Water as needed

1 Peel and grind the cardamom seeds in a coffee grinder or with a pestle. Beat the sugar, oil and malt together in a bowl.

2 Mix the flour and the baking soda together. Add the oil to the malt and sugar mixture and make a dough. You should get a thick cookie dough consistency, so add a little water if needed. Roll the cardamom in. Keep mixing with your hands until smooth. Roll the dough about a fourth of an inch thick.

3 Cut cookies shapes into it and bake in the oven on 350°F for fifteen minutes. Let them cool off and eat naked. Store in a closed container. Or eat cookies and make love until they are all gone.

CREMA DI CACAO E VANIGLIA
COCOA & VANILLA LIQUEUR

- INGREDIENTS -
2 cups water
1 1/4 cups pure alcohol for liqueurs
7/8 cup cocoa powder
1 tbsp vanilla powder
2 1/2 cups sugar

1 In a small pot, warm up the water without bringing it to a boil. Slowly add in the cocoa, stirring well to avoid clumps. Stir until smooth.

2 Add in the sugar, again without letting it boil, stirring in until it melts completely, then let cool well. Mix together the alcohol with the vanilla powder and add this to the cocoa cream, stirring well. Bottle and serve.

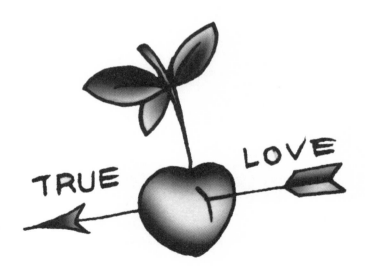

CUORICINI CON VEG-CAPRINO ED ERBA CIPOLLINA
HEARTS with "CAPRINO" CHEESE & CHIVES

- INGREDIENTS -

For the hearts:
2 tbsp margarine
1 tbsp white flour
1 1/4 cup unsweetened plain soy milk
1/2 tsp sea salt

For the filling:
2/3 cup veg-caprino cheese **(recipe on page 155)**
2 tbsp chives
Salt and pepper to taste
Semi-liquid batter made with flour and water, enough to coat each heart
Breadcrumbs, enough to coat each heart
Frying oil

You can also serve the veg-caprino cheese in shape of hearts without frying it, with a side of open figs and apricot jam.

1 Warm up the soy milk in a pan and add the margarine. Stir well until it boils. Remove from heat and add the flour plus 1/2 tsp salt. Mix well with a wooden spoon until you get a compact ball. Don't worry if it doesn't look smooth.

2 Let the dough cool then work with your hands on a floured surface until it is smooth. Meanwhile, mix the cheese, chives, salt, and pepper in a bowl. Roll the dough thin in a rectangular shape. Place spoonfuls of cheese (five inches apart) over half of the dough.

3 Fold the other side of the dough over and cut heart shapes using a cookie cutter around the cheese bumps. Keep reworking the dough until you use all the ingredients. Dip each heart in the flour and water batter and then roll in breadcrumbs. Deep fry each heart, absorb the extra oil with paper towels, and serve hot.

LASAGNE ZAFFERANO E ASPARAGI
SAFFRON & ASPARAGUS LASAGNA

- INGREDIENTS -
6 eggless lasagna sheets
1 tbsp margarine
1 tbsp white flour
2 tbsp extra virgin olive oil
1 tbsp nutritional yeast or veg parmesan
1 small onion, thinly sliced
5 oz asparagus
2 cups plain unsweetened soy milk
Salt
Pepper
2 large pinches of saffron

Choose an Italian brand of pasta. Barilla or De Cecco would make the best lasagna.

1 Cut the asparagus in thin rounds. Heat the oil in a pan with the onion and asparagus. Cook on medium heat for five minutes. Adjust the salt and pepper to taste and add the saffron, stirring well. Remove from heat. Boil a big pot of salted water, add few drops of oil and cook the lasagna sheets al dente.

2 Make a besciamella by melting the margarine in a small saucepan on low heat. Pour the flour in slowly and mix well to avoid lumps. Add the milk and stir well. When the milk boils, cook for three more minutes, stirring from the beginning to end.

3 Add the asparagus and mix well. Grease an oven dish as big as two lasagna sheets. Pour one layer of cream and nutritional yeast (or veg parmesan), one layer lasagna sheets, one layer of cream and so on for the three layers of lasagna. The last layer should be cream. Sprinkle with nutritional yeast or vegan parmesan and bake according to directions on the pasta box.

GRISSINI AI SEMI DI PAPAVERO
POPPY SEED BREADSTICKS

- INGREDIENTS -
2 cups white flour
I tsp dry yeast
I tsp sea salt
3 1/2 tbsp olive oil
3 tbsp poppy seeds
I 1/3 cups warm water

1 Preheat the oven to 400°F. Pour the flour and yeast in a big bowl, stirring well to avoid clumps. Dig a hole on the top and slowly pour the water and the oil. Work with your hands for ten minutes to make a smooth and compact dough. Cover with a cloth towel and let it rest for thirty minutes in a warm place.

2 Work the dough again for ten minutes and spread it out on a flat surface, making it half an inch thick and the size of a sheet of paper. Cut the sheet of dough in four pieces with a knife and then each rectangle in eight strips. Work each of them, making it about ten inches long. Pour a little flour in the oven dish and lay the strips one inch apart. Slightly wet the surface of the grissini with a brush and spread the poppy seeds over them.

3 Cook for fifteen to twenty minutes or until they become gold. Serve with grilled vegetables, like zucchini, eggplants, onions, tomatoes, and peppers, grilled with a pinch of salt and a little olive oil.

PASTA INTEGRALE ALLA CREMA DI PISELLI E SALVIA
WHOLE WHEAT PASTA with CREAMY SWEET PEAS & SAGE

- INGREDIENTS -
7 oz whole wheat pasta of your choice
3 1/2 full tbsp extra virgin olive oil
1 small yellow onion (even less, to taste)
1 cup cooked sweet peas (canned is okay)
8 big leaves of sage
Sea salt and pepper to taste
enough white flour to coat each sage leaf
1 tbsp toasted pine nuts
nutritional yeast (or vegan parmesan)
1 large pinch saffron (optional)

> I suggest using "tagliatelle" or "pizzoccheri" pasta. They can be found in Italian food stores.

1 Slice the onion thinly and toss it in a pan with 2 tbsp of oil, cooking until soft. Mix the cooked peas with the onions and oil in a food processor. If needed, add a little oil to make a creamy consistency. Adjust with salt and pepper. Melt the saffron in a little hot water and add it to the mix. Set aside.

2 Cook the pasta according to the directions on the box. While the pasta is cooking, make a thin batter of water and flour and dip the sage leaves in it. Fry them in oil on medium heat. Drain the pasta when it is ready and mix it in with the cream. Put the pot back on low heat for one minute, stirring well and adding the rest of the oil.

3 Toast the pine nuts in a pan with a little bit of oil on medium heat. Serve on a plate with the fried sage and pine nuts on top, sprinkled with nutritional yeast.

PERE AL BAROLO
PEARS SOAKED in BAROLO WINE

- Ingredients -
4 small pears
3 1/2 tbsp sugar
2 cloves
Zest of half a lemon
1 cup Barolo wine
1/3 cup water

1 Peel the pears and place them standing up in a pan. Pour sugar over them and add the cloves, lemon zest, wine, and water.

2 Cover and cook on low heat for one hour or until soft. Serve on a plate with the sauce poured over it.

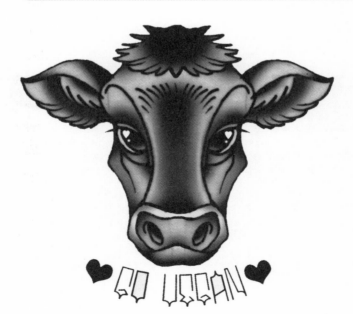

PIZZA PICCANTE DELL'AMORE
SPICY LOVE PIZZA

- INGREDIENTS -
Pizza dough, rolled in a square **(recipe on page 114)**
Tomato sauce for pizza
1 tsp Vaffanculo Mondo **(recipe on page 34)** OR
1 tsp dry spicy pepper

1 Preheat your oven to 430° F. Spread the tomato sauce and spicy pepper on the pizza dough. Fold to make the shape of an open envelope.

2 Bake for fifteen minutes or until the dough is ready.

RISO VENERE CON CREMA DI ZUCCHINE
BLACK RICE & CREAMY ZUCCHINI

- INGREDIENTS -
1 cup black rice
2 tbsp olive oil
1 small yellow onion, thinly sliced
2 zucchini, thinly sliced
1 tbsp fresh chives
1 tsp saffron powder (or 2 tbsp threads)
1 cup panna di soia **(recipe on page 153)**

1 Boil the rice in salted water according to cooking instructions, or for twenty-five minutes. Drain and set aside.

2 In a big pan, make a soffritto with olive oil, onion, and a half pinch of salt. Add the zucchini. Once they are browned, cover with a lid and cook on low heat for few minutes. Add the chives and mix well.

3 Add the rice and stir well. Melt the saffron in 4 tbsp warm water and mix it well with the rice. Pour in half the panna and keep stirring on low heat. Pour the rest of the panna di soia right before serving.

SPAGHETTI ALLA VEG-BOTTARGA
SPAGHETTI with VEG-BOTTARGA

Bottarga is a delicacy of salted, cured fish from coastlines throughout the world and is often featured in Mediterranean cuisine

- INGREDIENTS -
7 oz spaghetti
1 garlic clove, peeled
2 full tbsp breadcrumbs
Extra virgin olive oil
A few drops of lemon juice
1/4 cup white wine
A sprinkle of parsley
Salt for boiling the pasta
Pepper to taste
2 sun-dried tomatoes (not ones soaked in oil)
2 tbsp mixed seaweed, crumbled

1 Soak the sun-dried tomatoes in hot water for 10 minutes, then drain well. Heat 2 or 3 tbsp of oil in a large pan and toss the breadcrumbs until they are toasted, not burned. Remove from heat and set aside.

2 In another pan, heat more oil with garlic. Cut the tomatoes in small pieces (or you can grind them in a food processor) and stir them in, cooking for couple of minutes on low heat. Add the seaweed and keep stirring for few more minutes. Add the wine until it is absorbed.

3 Meanwhile cook the pasta according to its directions. Do not salt the water too much, since the seaweed and tomatoes already have a strong flavor. Drain and toss in the pan with the tomatoes. Add oil and breadcrumbs, sprinkle with parsley and pepper to taste, and serve.

SEITAN STEW with LEEK & SAFFRON SAUCE

- INGREDIENTS -
Seitan chunks for 2 people
1 large pinch saffron
1/2 vegetable bouillon cube
1/4 cup white wine
1 leek, thinly sliced
Extra virgin olive oil
Salt
Water
1 tbsp soy sauce
1/2 cup panna di soia **(recipe on page 153)**

1 Boil water with the bouillon cube. Let it dissolve completely and remove the pot from heat. Soak the seitan in it for fifteen minutes. Sauté the leek in a pan with a thread of oil until it is caramelized, careful not to burn it.

2 Meanwhile, dissolve the saffron in a glass of warm water. Add a little oil to the leeks and toss in the seitan. Stir for one or two minutes on medium heat and pour in the wine, cooking until fully absorbed. Add the soy sauce and three-fourths of the saffron water. Lower the heat and cook while covered until the liquid is absorbed.

3 Add the rest of the saffron water and panna while stirring. Continue cooking for couple more minutes, continuing to stir. Adjust with salt to taste and serve.

TAGLIATELLE AI PETALI DI ROSA
PASTA with ROSE PETALS

INGREDIENTS -
1 1/2 tbsp margarine
A pinch of nutmeg
2 tbsp olive oil
3/4 cup panna di soia **(recipe on page 153)**
Salt and white pepper to taste
2 organic pink roses
1 small leek
7 oz eggless tagliatelle or linguini

1 Remove the rose petals and carefully clean each one with a damp, clean kitchen towel. Cut in slices, saving a few small petals for decoration. Remove the green part and the roots of the leek and slice them thinly.

2 Bring a pot of unsalted water to a boil. Meanwhile, make a soffritto with oil, margarine, and the leek until soft. Add the panna and a pinch of nutmeg, stirring well. Add a pinch of salt and pepper. Let it cool and blend it to make a smooth cream. Pour the cream in a big nonstick pan and set aside, covered.

3 Cook the pasta in the boiling water according to the time directions on the box. Drain.

4 Add the roses to the cream, stir, and pour the pasta in the pan on low heat. Stir well and serve decorated with rose petals.

TARTUFINI CACAO E PEPERONCINO
COCOA & CHILI PEPPER TRUFFLES

- INGREDIENTS -
1 cup of dark chocolate bar pieces
3/4 cup panna di soia **(recipe on page 153)**
3 1/2 tbsp margarine
3 tbsp sugar
3 tbsp cognac
Enough ground almonds to coat each truffle
1 small pinch dry crushed hot pepper

1 Put the chocolate in a bowl. Heat the panna, margarine, and sugar in a small pot. Stir with a wooden spoon. Pour over the chocolate when it starts bubbling. Wait one minute and pour in the cognac and hot pepper. Mix until the chocolate is melted, stirring well.

2 Form balls with your hands and place them in a plate. Refrigerate for one hour. Roll them in the ground almonds and refrigerate for another half hour.

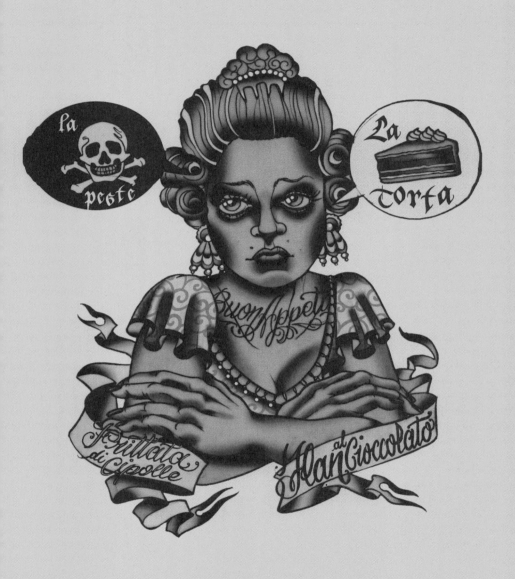

FRITTATA DI CIPOLLE
ONION OMELETTE

- INGREDIENTS -
2 cups chickpea flour
Sea salt and pepper to taste
Water
1 big yellow onion, peeled and thinly sliced
4 tbsp olive oil

1 *Make a smooth and liquidy but thick batter with the flour, salt, pepper and water.*

2 *In a 10 inch pan, caramelize the onion slices in 2 tbsp oil with a small pinch of salt on medium heat. Add 1 tbsp oil and pour the batter over half an inch thick. Cover with a lid and cook for seven minutes or until it solidifies. Add 1 more tbsp of oil and flip it to cook on both sides. Add oil if needed.*

You can make frittata with any veggies, such as zucchini, asparagus, sweet peas, and artichokes. Make a soffritto with onions and oil (you can add grated carrots and celery to make it richer) and caramelize it before you pour in the batter. For harder veggies such as asparagus, peas, etc, boil or steam them first.

FLAN AL CIOCCOLATO
CHOCOLATE FONDANT

This recipe is measured in grams so that the measurements are super precise. The chemistry of it is delicate and you cannot get that precision with cups.

- INGREDIENTS -
460 grams panna di soia **(recipe on page 153)**
150 grams soy milk
300 grams margarine
500 grams dark chocolate
375 grams sugar (a little more)
190 grams flour
1 tsp baking powder

1 Preheat your oven to 430°F. Mix the flour and baking powder and set aside. Put the rest of the ingredients in a pot and melt everything, stirring well.

2 Add in the flour, mixing with a hand blender. Pour 1/4 cup each in large muffin tin and bake for fifteen minutes.

3 Serve warm with a spoon of vanilla ice cream and sliced strawberries. Invite your friends to eat them immediately OR make as many as you can eat and save the rest of the batter. This does not store well.

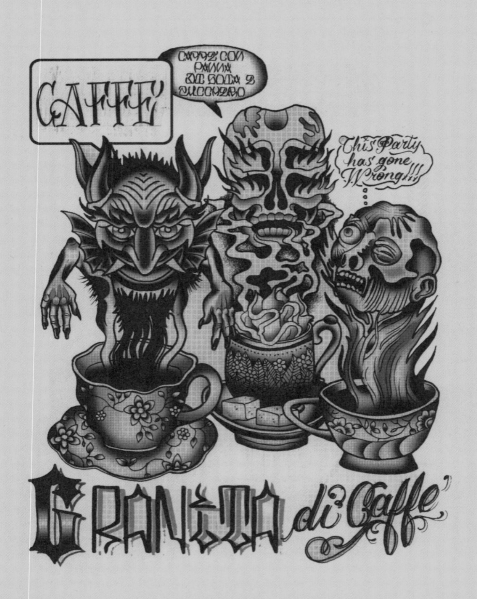

GRANITA SICILIANA DI CAFFé CON PANNA

SICILIAN CRUSHED ICE COFFEE with WHIPPED CREAM

- INGREDIENTS -
1/2 cup sugar
2 tsp agave syrup
2 1/2 cup water
1 cup espresso or coffee
Vegan whipped cream

The granita should be frozen but not solid, kinda like ice cream. Serve in glasses topped with whipped cream.

1 Melt the sugar and syrup in warm water on low heat. Keep stirring and let it boil for few minutes. Remove from heat, pour the coffee in, and stir well.

2 Let it cool a bit, stir again, and put it in the freezer. Stir every hour or so and serve after three hours or move it to the fridge until you are ready.

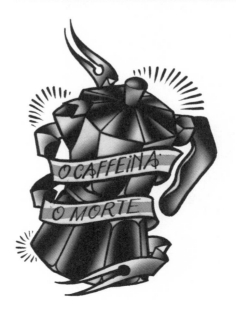

HAMBURGERS

HAMBURGER DI LENTICCHIE
LENTIL BURGER

- INGREDIENTS -
I carrot, peeled
I stalk of celery
1/2 onion, sliced
6 mushrooms (cremini work well)
I sun-dried tomato
pitted olives
I tbsp fresh herbs (oregano,
thyme, chives, or marjoram)
I tbsp nutritional yeast
A pinch salt
I cup cooked lentils
Breadcrumbs as needed

1 Pour all ingredients in a blender except for the lentils and blend for few seconds. Add the lentils and blend again, adding the breadcrumbs until it is firm.

2 Make burger shapes and cook in a pan with a little bit of olive oil.

HAMBURGER ESTIVO DI MELANZANA
EGGPLANT BURGER

- INGREDIENTS -
4 eggplants
Breadcrumbs
Fresh chopped parsley
1 tbsp flour
1 tbsp unsweetened plain soy milk
Extra virgin olive oil
Salt and pepper to taste

1 Wash, peel, and grate the eggplants. Salt them and let drain in the pasta strainer. Meanwhile, bring a pot of salted water to boil. Throw the eggplants in the boiling water and cook for few minutes. Drain well and let cool.

2 Dry off the extra water by pushing on them with a fork and pour them in a big bowl. Add the breadcrumbs, chopped parsley, flour, soy milk and salt if needed. Mix it until you get a thick consistency. Add flour or breadcrumbs if it is too liquid or soy milk if it is too dry. Form patties and bake in an oiled pan at 350°F for forty minutes. Broil at the end to make a crust.

You can do the same replacing eggplant with zucchini.

HAMBURGER DI FARRO
FARRO BURGER

- INGREDIENTS -
2 tbsp cooked farro
4 tbsp mix of onion, celery, carrot, pepper or chili pepper
2 oz firm tofu
2 tbsp cornstarch
Olive oil as needed
Salt to taste
Fresh rosemary to garnish

1 Blend in a blender, make a burger shape, and cook as preferred... in the oven or on a pan with oil.

Serve with steamed veggies such as pumpkin, onion, carrots, asparagus, and beets salted with gomasio.

HAMBURGER BUONO
GOOD BURGER

- INGREDIENTS -
2 tbsp cooked oats
2 tbsp cooked millet
2 tbsp cooked quinoa
1 big peeled, boiled carrot
1 tbsp breadcrumbs, adjust to consistency
1 tsp rice or barley malt
1 tbsp chickpea flour, adjust to consistency
Salt to taste
Spices or herbs

1 *Blend the grains and the carrot in a food processor or blender. Add the malt, salt, and spices and mix. Add breadcrumbs and chickpea flour until it is the right consistency to form patties. Shape the patties and cook in a pan with 1 tbsp olive oil.*

Serve with whole wheat bread and a spread or on a bed of baby spinach, onions and tomatoes.

HAMBURGER DI CAVOLFIORE
CAULIFLOWER BURGER

- INGREDIENTS -
2 1/2 cups cauliflower
3 tbsp veg-ricotta **(recipe on page 154)**
6 tbsp breadcrumbs
Black pepper
Curry powder
1 tsp extra virgin olive oil, plus 1 tsp for cooking
1 fresh sage leaf
Sea salt to taste

1 *Steam the cauliflower until soft. Mash all the ingredients together with a fork, adding a little flour if needed. Make patties and cook them in a pan with the sage and 1 tbsp olive oil.*

Serve on whole wheat bread.

HAMBURGER SCOREGGIONE DI FAGIOLI
HAPPY FART BURGER

 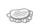 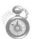

- INGREDIENTS -
1 cup cooked beans
2 boiled or steamed potatoes
Chickpea flour or cornmeal
Sea salt and pepper to taste
Sesame seeds
Olive oil

1 Mix the beans, potatoes, flour and salt/pepper in a blender or food processor. Shape into burgers with oil-greased hands. Roll in sesame seeds and cook in a pan with a drop of oil.

Serve with bread and steamed kale or greens dressed with salt, extra virgin olive oil, and lemon.

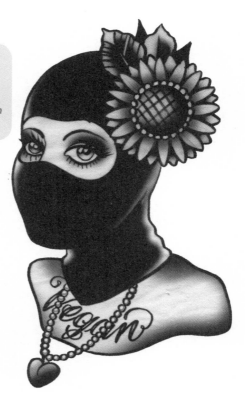

HAMBURGER DI BROCCOLI
BROCCOLI BURGER

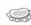

- INGREDIENTS -
2 cups broccoli
Sea salt to taste
1 small potato
2 tbsp manitoba flour
1 tbsp unsweetened plain soy milk
Sesame seeds

1 *Steam the broccoli and potato until soft. Mash all the ingredients except for the sesame seeds. If needed, add a little soy milk to make it softer or manitoba flour to make it more solid.*

2 *Form a patty. Sprinkle with sesame seeds and toast on a nonstick pan with olive oil.*

Serve with a salad and cooked grains such as barley or quinoa and garbanzo beans, dressed with gomasio and tahini.

PATATE ARROSTO
OVEN ROASTED POTATOES

- INGREDIENTS -
Big potatoes, as many as desired
Olive oil
Salt and pepper to taste
Fresh rosemary

1 Cut the potatoes in chunks and place in a greased casserole dish. Sprinkle with salt pepper and rosemary. Cover with a thread of oil and bake on 350°F for thirty minutes. Broil at the end to make a golden crust and sprinkle with salt to taste.

PATATE STRABUONE
THIN ROASTED POTATOES

- INGREDIENTS -
3 big potatoes
Extra virgin olive oil
Fresh rosemary
Salt and pepper to taste
Breadcrumbs, enough to garnish

1 Wash, peel, and cut the potatoes in thin round slices. Salt them and pour a lot of oil on the bottom of the pan. Throw the potatoes in with rosemary and bake at 350°F until cooked but not burned. Remove from the oven, sprinkle with breadcrumbs and a thin thread of oil, and broil them until they are gold and almost crunchy. Serve hot with vegan mayo.

CAVOLETTI DI BRUXELLES GRATINATI
OVEN ROASTED BRUSSEL SPROUTS

- INGREDIENTS -
Brussel sprouts
Olive oil
Salt and pepper to taste
Breadcrumbs

1 Wash and remove the external leaves of the sprouts. Boil them until al dente in salted water and drain them. Lightly oil a casserole dish, pour in the sprouts, cover with breadcrumbs, and drop a thread of oil over. Bake for ten minutes at 380°F, then broil until they make a golden crust on the surface.

VERZA ARROSTO
PAN ROASTED SAVOY CABBAGE

- INGREDIENTS -
Savoy cabbage
Olive oil
Soy sauce to taste
2 garlic cloves
Sea salt to taste if needed

1 Wash and remove the external leaves of the cabbage, then slice and boil in unsalted water for ten minutes. Peel and chop the garlic cloves and caramelize with olive oil in a pan. Add the boiled cabbage. Keep stirring with a wood spoon for five minutes on medium heat. Switch to low heat, add drops of soy sauce to taste, and keep stirring until it is all absorbed and the cabbage starts to look like it's going to burn. Add salt if needed and serve.

CARCIOFI TRIFOLATI
PAN ROASTED ARTICHOKES

- INGREDIENTS -

6 artichokes
2 to 3 tbsp extra virgin olive oil
1 big garlic clove
Sea salt to taste
Ground pepper
Fresh parsley to garnish

1 Wash the artichokes and remove the external leaves. Cut the ends with a sharp knife and remove the stem. Cut that in half and remove the hair.

2 Peel the garlic and chop it in half. Warm up 2 to 3 tbsp extra virgin olive oil and add the garlic. Add the artichokes and sauté' for few minutes with salt and pepper.

3 Add 1 cup water and lower the heat, cooking covered until the water is absorbed and the artichokes are soft. Add more water if necessary. Sprinkle with parsley, stir a little more, and serve.

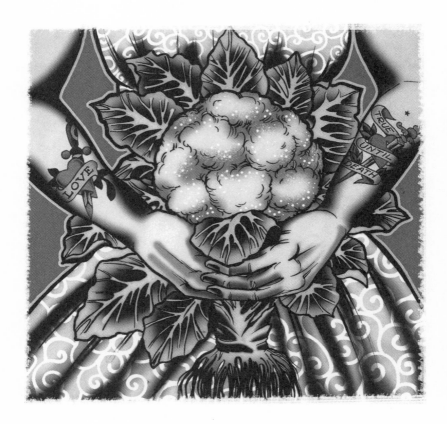

I CAPÚ
ROLLS of SAVOY CABBAGE

- INGREDIENTS -
- 6 leaves of savoy cabbage
- 1 cup ground fake meat or seitan
- 1 peeled, minced garlic clove
- spices of your choice
- 1/2 bunch parsley
- salt
- ground pepper
- unsweetened plain soy milk
- 1 cup breadcrumbs
- nutritional yeast
- egg replacer for 1 egg
- extra virgin olive oil
- 1 small onion, thinly sliced

Variation: Add 1 cup of tomato sauce to the pan and cook the cabbage rolls in it.

1 Mix the ground soy meat, nutritional yeast (or vegan parmesan), breadcrumbs, egg replacer, parsley, garlic, and spices with soy milk until you get a paste that can be used as stuffing. Make six balls and place them on the leaves. Roll them up and tie them with kitchen thread or hold them in place with toothpicks.

2 Make a soffritto with oil and the onion and place with the rolls in the pan. Sprinkle with a little bit of salt, cover with a lid, and cook on low heat for a half hour or until the cabbage is soft. Make sure you flip them over a couple of times.

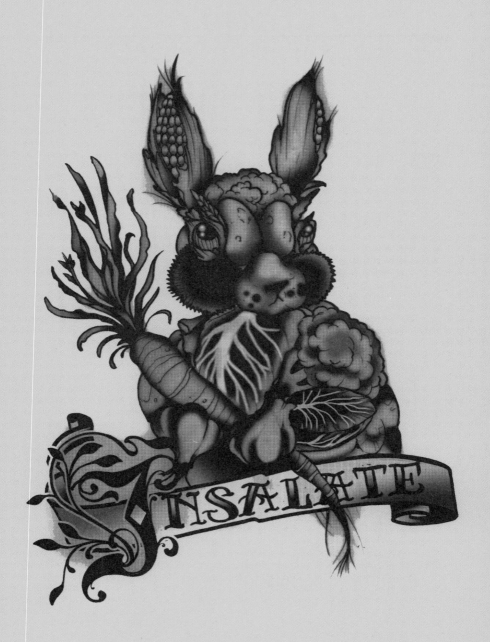

INSALATA DI RISO
COLD RICE SALAD

for three to four people

- INGREDIENTS -
I full cup of white rice
I full tbsp capers to taste
5 tbsp pitted olives per person
2 tbsp pine nuts to taste
2 veggie dogs, sliced
1/2 to I can of corn
I small can of carrots and sweet peas to taste
I can of artichokes hearts to taste, cut in pieces
I small can of mushrooms to taste, sliced thin
I piece of nori seaweed, thinly sliced
Sea salt to taste
Fresh parsley to taste, chopped
2 tbsp vegan mayo (or more if you like)

1 Cook the rice in salted water, drain, and let cool. Mix with all the other ingredients. Add the mayo at the end so you can adjust the quantity. Serve immediately or keep in the refrigerator.

This is a popular summer dish and can be stored in the fridge for few days. You can add anything, such as sun-dried tomatoes, cooked vegetables, or spices.

INSALATA VERDE SEMPLICE
SIMPLE GREEN SALAD

- INGREDIENTS -
Mix of different greens (arugula, baby spinach, spring mix...)
Cherry tomatoes
Black olives
Sunflower seeds
Extra virgin olive oil
Salt
Balsamic vinegar

1 *Mix the ingredients and dress with the vinegar.*

INSALATA DI FARRO E FAGIOLINI
FARRO & STRING BEAN SALAD

 for four to five people

- INGREDIENTS -
5 cups cooked farro
30-40 cherry tomatoes
1 bag or 10 oz string beans
5 leaves fresh basil per person, or to taste
1 garlic clove, cut into pieces
Sea salt for the boiling water plus more to taste for dressing
Extra virgin olive oil to taste for dressing

1 *Boil the string beans in salted water until soft. Cut the cherry tomatoes in half, sprinkle with salt, and put in a bowl with the garlic. Set aside for few minutes. Add the string beans to the farro and add in freshly chopped basil. Remove the garlic from the tomatoes and add them to the farro and string beans. Adjust with salt and pepper and dress with extra virgin olive oil. Also delicious if you dress it with pesto (recipe on page 107).*

INSALATA INVERNALE
WINTER SALAD

- INGREDIENTS -
1 orange, cut in slices
1 fennel bulb, cut in slices
Pine nuts

For the dressing:
Sea salt
Extra virgin olive oil
Balsamic vinegar
Juice of 1/2 orange

1 Mix the ingredients and dress.

INSALATA CALDA DI CAVOLO
WARM CABBAGE SALAD

- INGREDIENTS -
1/2 white and 1/2 purple cabbage
A handful of pitted black olives
1 or 2 tbsp capers (to taste)
1 1/2 tbsp extra virgin olive oil (or more to taste)
Sea salt to taste
1 small branch fresh rosemary
1 tsp soy sauce

1 Warm up 1 1/2 tsp oil in a deep pan. Slice the cabbage and sauté for few minutes. Add a little warm water and let it absorb until the cabbage is firm but soft. Add the olives, capers, and rosemary and keep stirring. At the end, add the soy sauce and cook until it all gets absorbed. Adjust with salt.

INSALATA ESTIVA
SUMMER SALAD

- INGREDIENTS -
Mixed lettuce
1 nectarine, sliced
1 cucumber, sliced
Almonds

For dressing:
Sea salt
Extra virgin olive oil
1 tsp soy sauce
Lemon juice

1 Mix the ingredients and dress according to your taste.

INSALATA ESTIVA DI MIGLIO
SUMMER MILLET SALAD

- INGREDIENTS -
Cooked millet
Canned corn
Cooked chickpeas
Tomatoes, sliced
Cucumber, sliced
Walnuts, chopped
Flax seeds
Sesame seeds
Sea salt to taste
Extra virgin olive oil

1 Mix together and dress according to your taste and party size.

INSALATA RUSSA
POTATO SALAD

- INGREDIENTS -
1 large peeled potato
2 medium peeled carrots
1 cup sweet peas cooked in salted water (canned is okay)
A pinch salt
1 tbsp capers, well drained
Vegan mayo, twice as much as your quantity of veggies
Parsley for garnishing

1 *Cut the potatoes and carrots in pieces and steam them with a pinch of salt. When they are cooked al dente, add the sweet peas and then vegan mayo. Add the capers. Mix well and decorate with fresh parsley.*

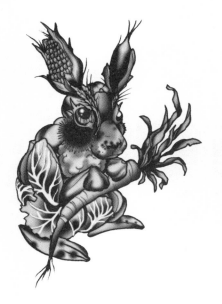

Serve as an appetizer with bread or as a side.

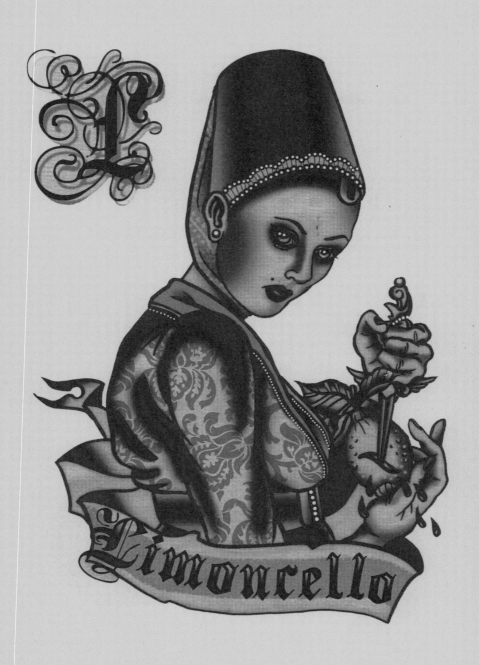

LIMONCELLO
LEMON LIQUEUR

> Choose thick-skinned lemons because they are easier to zest. The lemons must be yellow and not tinted with green.

- INGREDIENTS -
15 organic lemons
1 (750 ml) bottle of Everclear alcohol (190-proof)
4 cups granulated sugar
5 cups water (filtered tap water or distilled water)

1 Wash the lemons well with hot water. Pat them dry. Carefully zest them with a vegetable peeler so there is no white pith on the peel.

2 Pour the alcohol in a 1 gallon glass jar with a lid. Add the lemon zest as it is peeled. Cover the jar and let sit at room temperature for at least ten days and then for up to forty days in a cool dark place. Stir occasionally.

3 After this period of time, combine the sugar and water in a large saucepan. Bring it to a gentle boil for approximately five to seven minutes. Remove from the heat and let the syrup cool before adding it to the Limoncello mixture.

4 Cover the jar and allow to rest for another ten to forty days. After the rest period, strain the Limoncello and discard the lemon zest. Pour strained Limoncello into a bottle/bottles of your choice and seal them tightly. Conserve in the freezer, and serve straight out of it in ice-cold glasses.

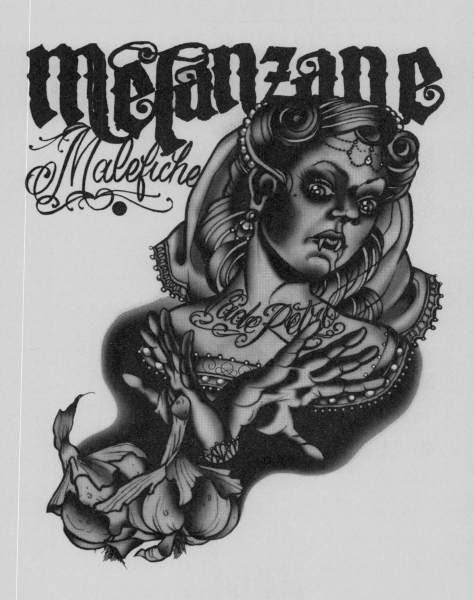

MELANZANE CON CAPPERI E OLIVE
SERVIETTE CON PANE TOSTATO E CREMA DI CECI
EGGPLANTS with CAPERS & OLIVES

- INGREDIENTS -

For the eggplants:
2 eggplants
A large handful of pitted black olives
2 tbsp capers (or more to taste)
I big peeled garlic clove
I 1/2 tbsp extra virgin olive oil
20 leaves of fresh basil

For the chickpeas spread:
I cup cooked chickpeas
1/2 onion, thinly sliced
I garlic clove
Crushed chili pepper
A few sprigs of fresh parsley
The juice of half a lemon
Extra virgin olive oil
Sea salt to taste

1 Cut the garlic clove into four pieces and warm them in oil in a big pan. Dice the eggplants and add to the pan, stirring well. Cook on medium heat for few minutes. Add salt and lower the heat, cooking while covered. Add the olives, capers and basil. Stir well for a couple more minutes.

2 Blend everything for the chickpea spread in a blender, adding the oil slowly until you get a creamy consistency. Serve with toasted Italian bread.

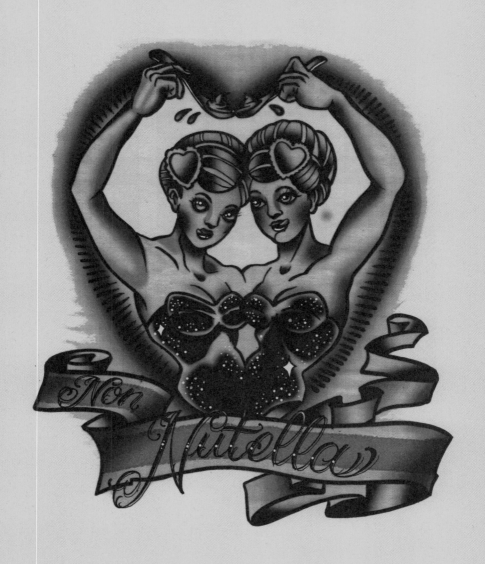

NON NUTELLA
NOT NUTELLA

- INGREDIENTS -
1 full cup dark chocolate, crushed
3/4 cup plain soy milk
3/4 cup hazelnuts
A little less than 1 cup powdered sugar
Less than 1/4 cup seed oil
1/4 tbsp vanilla powder

1 Blend the hazelnuts until they have a consistency like paste. Put all the ingredients in a nonstick pan and let melt on low heat while stirring with a spoon.

2 When you get a smooth cream, pour it in a glass container and let it cool. You can store it in a sealed container for fifteen days outside the fridge.

OLIVE ALL'ASCOLANA
STUFFED OLIVES

- INGREDIENTS -
2 cups large, pitted green olives
1/2 cup ground veggie meat
2 tbsp firm tofu, crumbled
1 veggie dog, cut into tiny pieces
2 tbsp tomato sauce
1 tbsp breadcrumbs
Extra virgin olive oil
A pinch of nutmeg

For the frying batter:
Enough rice flour to coat each olive twice
Sparkling water
1 tsp curry powder
Enough breadcrumbs to coat each olive twice
Olive oil

1 In a nonstick pan, heat 1 tsp olive oil and ground meat for a few minutes. Add a pinch of nutmeg, the tofu, veggie dog pieces, breadcrumbs, and tomato sauce. Stir until it gets tight. Carefully fill each olive with the "meats" and set aside.

2 Make a thick batter with the flour, curry and sparkling water. Prepare a plate full of breadcrumbs on a side. Drop each olive in the batter and then roll into the breadcrumbs. Repeat this step twice and then refrigerate for few hours.

3 Grease an oven dish with olive oil and coat the olives in the oil by rolling them around. Bake at 390°F for ten minutes or until they turn golden. Roll them over a few times. Serve warm.

ORECCHIETTE CON LE CIME DI RAPA
PASTA with BROCCOLI RABE

- INGREDIENTS -

1 head broccoli or a bunch of broccoli rabe
2 big garlic cloves, cut in half
Extra virgin olive oil
Crushed dry hot pepper
7 oz orecchiette pasta
1 tbsp nutritional yeast

1 Fill a big pot with water and bring to boil, adding salt to taste (I use 1 1/2 tbsp). Drop in the broccoli or broccoli rabe. Boil until soft. Remove from the water with a strainer spoon.

2 Meanwhile, warm up 2 or 3 tbsp oil with the garlic. When the garlic becomes gold, add the cooked broccoli and the hot pepper and cook on low heat for about five minutes, stirring. Set aside and cover.

3 Cook the orecchiette in the boiling water from the broccoli, adding salt if needed. When the pasta is ready, put the broccoli back on medium heat. Drain the pasta and mix it with the broccoli. Keep stirring and add oil if needed. Add 1 tbsp nutritional yeast, mix, and serve.

For a fancy variation:
Drop a spoonful of vegan
ricotta cheese on top
(recipe on page 154).

OLIO AROMATIZZATO AL PEPERONCINO
SPICY OIL

 - INGREDIENTS -
1 overflowing cup extra virgin olive oil
1/4 cup dried hot peppers (or any quantity in this proportion)

1 Put the peppers in a bottle full of oil. Let it sit in a dark place for at least 1 week before using. Use on pasta, veggies or pretty much anything. It gets spicier and spicier the longer you have it. You can also add few cloves of garlic and filter the oil few weeks later.

"OSSOBUCO" ALLA MILANESE
MILAN STYLE "OSSOBUCO"

 for four people

- INGREDIENT -
12 oz seitan for four big chunks
Enough white flour to coat the seitan
3 full tbsp margarine
1/3 onion, minced
1 ladle full of vegetable broth
1 tbsp tomato paste
A dash of sea salt
Zest of 1 lemon
1/2 garlic clove
2 tbsp freshly chopped parsley
1 small piece of nori seaweed, cut in small stripes

1 Heat the margarine in a pan. Roll the seitan in flour, add it to the pan, and cook for few minutes.

2 Pour the broth, tomato paste, and salt in and cook covered for fifteen minutes. Uncover and cook until the broth is absorbed.

3 Grind the garlic, parsley, lemon together and add to the seitan. Keep stirring for five more minutes. Serve on plates with risotto.

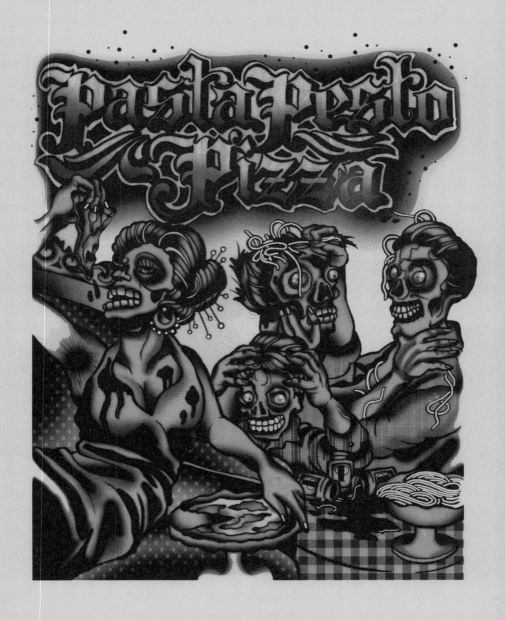

PESTO TRADIZIONALE
TRADITIONAL PESTO

- INGREDIENTS -
- 1 1/2 cup fresh Italian basil leaves
- 1/2 cup extra virgin olive oil (or more)
- 1 peeled garlic clove
- 2 tbsp pine nuts
- 1/2 tsp salt

Excellent with "trofie" pasta but goes well with any pasta or as a spread.

1 Mix in a blender until creamy. Adjust the quantity of ingredients to your taste.

PESTO ROSSO
RED PESTO

- INGREDIENTS -
- 1 cup and more peeled chopped tomatoes
- 1 peeled garlic clove
- 1/2 cup peeled, crushed almonds
- A bunch of fresh leaves Italian basil
- A dash of pepper
- 2 sun-dried tomatoes
- 1/2 tbsp nutritional yeast

Canned tomatoes are okay as long as they do not have strange ingredients.

1 Mix all the ingredients together in a blender. Add a thread of extra virgin olive oil if needed.

PESTO DI PISTACCHI ALLA SICILIANA
SICILIAN PISTACHIO PESTO

- INGREDIENTS -
2 cups peeled, chopped pistachios
A few fresh Italian basil leaves
1 peeled garlic clove
A pinch sea salt
Extra virgin olive oil
1/2 tbsp nutritional yeast

1 Mix in a blender until creamy, adding the oil slowly in a thread.

PESTO DI AVOCADO
AVOCADO PESTO

 for three people

- INGREDIENTS -
2 small ripe avocados
2 full tbsp pine nuts
Salt to taste
1 peeled garlic clove
20 leaves of Italian basil, or more
to taste

This recipe is not quite Italian since we don't grow avocados, but it is delicious.

1 Mix in a blender until creamy, adding the oil in a thread. Consume on the same day, as it does not store well.

PASTA ALLA NORMA
PASTA with FRIED EGGPLANTS

 for two people

- INGREDIENTS -
7 oz penne or rigatoni pasta
I small eggplant
1/2 onion, thinly sliced
Sea salt as needed
I small pinch sugar
10 oz plain tomato sauce
1/2 cup Veg-Ricotta Salata **(recipe on page 156)**
A few leaves of fresh Italian basil to garnish
Frying oil

1 Slice the eggplant in 1/4 inch rounds. Put them on a big plate, salt, and cover with a pile of plates or something heavy for thirty minutes. Drain the salted water that was released with a cloth and set aside.

2 Cook oil in a deep pan with onions on low heat until they become translucent. Add the tomato sauce, one small pinch of sugar, and salt to taste. Cook on low heat until the sauce reduces to a third. Set aside.

3 Deep fry the eggplants until golden and absorb the extra oil with paper towels. Meanwhile, cook the pasta in salted water until al dente. Coordinate the time so that the eggplants are ready with the pasta. Grate half of the ricotta. Mix the pasta with the tomato sauce and half the ricotta. Put on plates with the fried eggplants on top. Grate the rest of the ricotta and garnish with the basil.

PASTA INTEGRALE AL PANGRATTATO
WHOLE WHEAT PASTA with BREADCRUMBS & CAPERS

for two people

- INGREDIENTS -
7 oz whole wheat spaghetti or linguini
3 tbsp breadcrumbs, more to taste
Drained capers to taste
Extra virgin olive oil
1 peeled garlic clove, cut into fourths

1 In a nonstick pan, toast the breadcrumbs until golden. Set aside in a bowl. Cook the pasta in salted water, according to directions or al dente.

2 Meanwhile, heat 2 tbsp extra virgin olive oil in a nonstick pan with the garlic. Add the breadcrumbs and mix with the capers. Strain the pasta well and throw it in the pan, adding 1 tbsp oil. Stir well for one minute.

PASTA E FAGIOLI
PASTA with BEANS

- INGREDIENTS -

1 cup dry beans that have been soaked overnight (white beans, kidney beans, borlotti beans)
1 stalk of celery
1 can plain tomato sauce
1 peeled carrot
1 peeled onion
1 peeled garlic clove
Salt and pepper to taste
Extra virgin olive oil
7 oz short pasta
2 dried bay leaves
1 branch rosemary
A good amount of vegetable broth
1 tbsp tomato paste

1 Wash and dice the onion, garlic, carrot and celery. Sauté them in a deep pan with oil. Add the beans and stir for few minutes. Add the tomato sauce and paste, stirring well for few minutes. Add two ladles of vegetable broth, lower the heat, and cover.

2 Stir well, adding broth to cover three-fourths of the pan. Add the bay leaves and rosemary, cooking on low heat semi-covered. There should be one-fourth of an inch of liquid above the surface of the beans. Cook until the beans are soft.

3 Cook the pasta al dente in lightly salted water. Drain and add to the beans, stirring well for few more minutes and until the mix is thick but still a little soupy.

4 Add salt and pepper and remove the rosemary and bay leaves. Pour in a thread of oil. You can decide the thickness and consistency of this plate according to your taste. It can be more like a soup or like a pasta dish with a light sauce.

PISAREI E FASO
"PISAREI" PASTA & BEANS

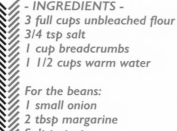

- INGREDIENTS -
3 full cups unbleached flour
3/4 tsp salt
I cup breadcrumbs
I 1/2 cups warm water

For the beans:
I small onion
2 tbsp margarine
Salt to taste
Extra virgin olive oil
nutritional yeast
I cup cooked beans
I cup tomato sauce
I tbsp tomato paste

1 In a bowl, mix the flour with salt and breadcrumbs. Slowly pour the water in, kneading with your hands to make a smooth and elastic dough. Wrap it in plastic wrap and let it sit for one hour.

2 Form a half an inch round roll and cut it into pieces as big as a bean. Press each one of them lightly in the center with your finger to dig a semi-hole in it. Make sure it doesn't go all the way through and just makes it flat at the center. Let them dry on a kitchen towel.

3 Melt the margarine with a couple tbsp of oil in a pan, adding in the onions and cooking them until soft. Add the beans, stirring well for one minute. Add the tomato sauce and paste. Salt to taste and keep stirring until you get the sauce to a creamy consistency.

4 Cook the pasta in boiling salted water until it comes to the surface. Drain and add to the pan with the sauce. Keep stirring on low heat for couple of minutes, adding oil and salt, adjusting to taste. Serve sprinkled with nutritional yeast.

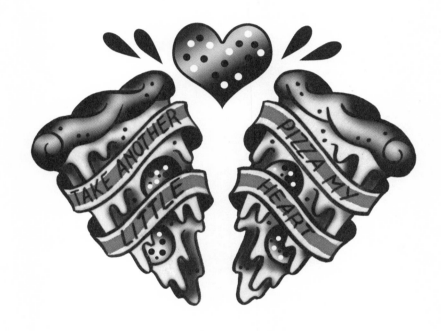

PIZZA AL TRANCIO
THICK PIZZA

- INGREDIENTS -

For the dough:
5 cups warm water
10 cups white flour
1/2 tbsp fresh yeast
1 full tbsp salt
1/3 cup and more olive oil

For the tomato sauce:
3 or 4 cans of plain tomato sauce or peeled tomatoes
1 tsp salt
1 small pinch sugar
1 tbsp extra virgin olive oil
1 peeled garlic clove, cut in half

Use a bread machine for this recipe if you have one.

1 Pour the water in a big bowl with the yeast and stir, adding half the flour. Knead the dough for few minutes and then add the salt with flour. Knead again and add the oil, letting it absorb well. Add the rest of the flour. Keep kneading for thirty minutes. Cover it with a clean cloth and let it rise for four hours in the oven while it's turned off.

2 Cut in three balls and place separately in small closed containers. Let them sit for two hours. Each ball will make one oven dish 20"x20".

3 Grease a pan generously, rolling the dough over and let it sit for three more hours in the oven, still turned off.

4 Preheat your oven to 480°F. Mix all the ingredients for the sauce in a bowl. When the dough is ready, pour the tomato sauce over, adjust with salt and add a thread of oil over the pie. Bake for ten minutes or until the dough gets crispy. Cut into squares and serve.

You can add pretty much anything to this, such as grilled veggies, olives, sun-dried tomatoes, fresh basil, fresh cherry tomatoes, mozzarella (recipe on page 152), and fried eggplant slices.

PIZZA FRITTA
FRIED PIZZA (typical of Naples)

- INGREDIENTS -
Pizza dough (recipe on previous page)
3 tbsp extra virgin olive oil, more to garnish
1 large bowl of tomato sauce
 OR 2 or 3 cans of pureed tomatoes, with salt and oil
Fresh Italian basil to garnish
A sprinkle of nutritional yeast

1 Form balls with dough and press them to get disks that are five inches wide. Fry them in a pan with oil, and cook for one minute on each side. Remove them from the pan, pour tomato sauce on top, garnish with a basil leaf, and sprinkle with nutritional yeast.

PIZZA NAPOLETANA DI SCAROLA
ESCAROLE STUFFED PIZZA from NAPLES

- INGREDIENTS -
2 1/2 cups white flour
1/2 cube fresh yeast
1/2 cup olive oil
1/2 cup dry white wine
A pinch salt

For the stuffing:
53 oz washed and sliced escarole
3 peeled garlic cloves
1 cup small, pitted black olives
1 3.5 oz jar of drained small capers
2 full tbsp toasted pine nuts
Salt and pepper as needed
1 cup raisins

1 Mix the flour with the oil, wine, and a pinch of salt. Mix the yeast with a glass of warm water and add to the flour, mixing it thoroughly with your hands Let it rise while covered with a clean cloth in the oven. When it has grown fully (give it a few hours), divide the dough into two balls, one slightly bigger than the other. With a rolling pin, flatten into two circles and press the bigger one onto the bottom and sides of an olive oil-greased pie dish.

2 Meanwhile, soften the raisins in warm water for ten minutes and drain well. Boil the escarole in lightly salted water for fifteen minutes, then drain well.

3 In a big pan, heat up all the oil with the garlic. When it becomes gold, add the olives, capers, pine nuts, and raisins. Stir for a couple of minutes and add the escarole, salt, and pepper to taste. Cook for ten minutes on low heat, stirring until all the water is evaporated. Fill the dough with the veggies, placing the other dough on top. Seal the sides shut. Set aside for one hour in the oven while turned off.

4 Bake at 390°F for thirty minutes or until the bread dough is ready, and serve warm.

PIZZATA LIGURE
FLAT PIZZA LIGURIA STYLE

You can substitute the tomato sauce with a veg-crescenza cheese sauce (see recipe on the next page) to obtain the famous Focaccia di Recco. DIVINE!

- INGREDIENTS -
2 cups white or manitoba flour
A pinch salt
Extra virgin olive oil
Tomato sauce for pizza **(recipe on page 114)**

1 *Preheat your oven to 390°F. Mix the flour with 3 Tbsp oil and a pinch of salt in a bowl. Knead it well. Add warm water if needed. When the dough is smooth, divide it in two and roll them into two thin squares. They should be the size of your pizza pan.*

2 *Lightly grease the bottom of the pan, place one of the squares of dough on it, and cover with the tomato sauce. Save 4 tbsp of the sauce for the other square of dough. Add the tomato sauce on top plus a thread of oil to that and bake both for thirty minutes.*

VEG-CRESCENZA SAUCE

- INGREDIENTS -
For crescenza cheese:
1/3 cup plain, unsweetened soy milk
1 full tbsp white flour
Less than 1 tsp corn starch
1 tbsp lemon juice
A pinch of salt
1 1/2 tbsp plain, unsweetened soy yogurt
1 tsp linseed oil

For the sauce:
17 oz of crescenza
1/2 cup plain, unsweetened soy milk
1/2 cup panna di soia **(recipe on page 153)**
A pinch of salt

1 Pour the milk in a small pan and slowly add in the flour and cornstarch, stirring well with a wooden spoon. Add the salt and lemon juice, cooking on low heat until you get a thick and smooth cheese. Remove from heat and let it cool for few minutes. Add the soy yogurt and linseed oil. Stir well and refrigerate for few hours.

2 Stir the crescenza cheese with the soy milk, panna di soia and a pinch of salt.

QUADRATI DI PANNA COTTA
CON SALSINA DI BOSCO O SALSINA AL CIOCCOLATO

PANNA COTTA SQUARES with BERRIES & CHOCOLATE SAUCE

- INGREDIENTS -

For the panna cotta:
1 tsp agar agar
1 2/3 cup milk (your choice; half soy, half coconut is nice)
1 1/3 cup panna di soia **(recipe on page 153)**
2/4 cup whole sugar
A pinch of grated vanilla
Zest of 1 small organic lemon

For the berry sauce:
1 full cup raspberries
1 full tbsp raw sugar
2/3 cup water

For the chocolate sauce:
1/2 cup dark chocolate chunks
4 tbsp vanilla soy milk
1 tbsp coconut milk (the kind that comes in a can)
1 tbsp panna di soia
Grated coconut or almond pieces and hazelnuts to garnish

1 Pour the milk, panna, and agar agar in a small pot on low heat. Stir well and let bubble for fifteen minutes. Add the sugar, vanilla and lemon zest. Stir well and remove from heat. Pour the mixture into square or round shapes about 2 1/2 inches deep that hold about one cup.

2 Refrigerate for few hours. Drop onto serving plates and cover with the sauce.

3 Pour the ingredients for the berry sauce into a small pot and cook for four minutes on low heat. Keep stirring until it becomes smooth and thick. Pour over the panna cotta.

4 Melt the chocolate in a nonstick pan with the milk and panna, stirring well. When it reaches a thick consistency, pour over the panna cotta and garnish.

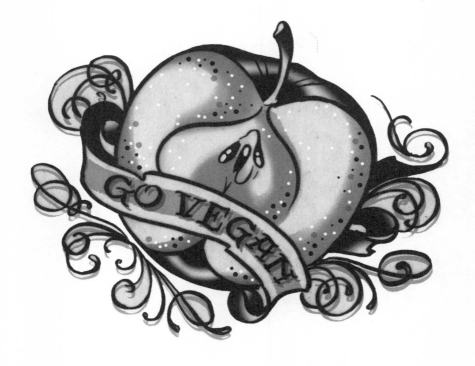

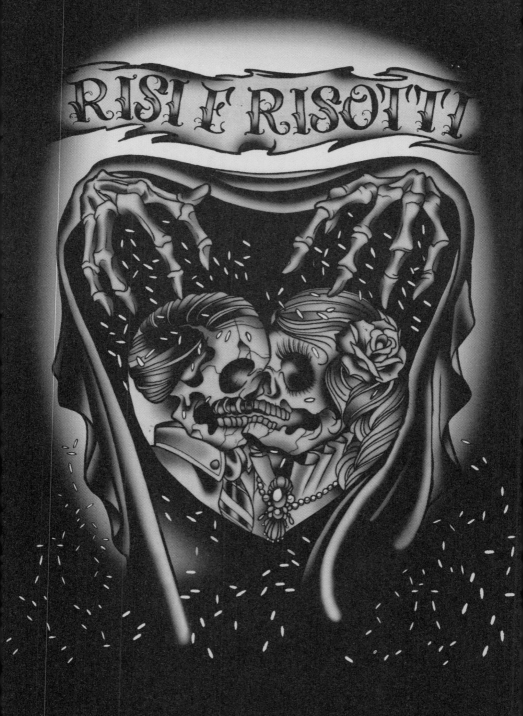

RISI E BISI
RICE SOUP with SWEET PEAS

- INGREDIENTS -
1 cup soup rice ("vialone nano" if you can find it)
Vegetable broth as needed
1 small onion
3 tbsp margarine
Extra virgin olive oil as needed
Salt as needed
1/4 cup fresh parsley
1 full tbsp nutritional yeast
30 oz fresh sweet peas

1 Wash the peas and remove from their pods. Pour broth in a pot and cook the pods while covered for one hour on medium heat. When they are ready, make a purée of the pods and the remaining broth in a blender. Filter the cream with a tight strainer over a bowl to get rid of the fibers, pressing well with a spoon to drain.

2 Put the liquid aside and prepare the broth for later. Heat half of the margarine in a pan and add the onion, cooking it on low heat for five to ten minutes. Add the peas, parsley, and 1 tbsp oil. Add 2 ladles of broth and cook on low heat for few minutes. Pour in the pod purée, add salt, stir well, and add the rice. Cook until the rice is soft.

3 You can choose the consistency to your taste. If you like it less soupy, raise the heat and cook until almost all the broth is absorbed. If you like it more liquidy, add more broth.

4 When your risi&bisi is ready, add the rest of the margarine, stir well, and sprinkle with nutritional yeast before serving. Garnish with parsley.

RISOTTO AI BORLOTTI E POMODORO
BEAN & TOMATO RISOTTO

- INGREDIENTS -
1 1/2 cup arborio rice
1 small yellow onion, thinly sliced
1 cup cooked kidney beans
Extra virgin olive oil
1 glass red wine
Vegetable broth as needed
1 cup tomato sauce (plain, chopped tomatoes are okay)
1 tsp tomato paste
Nutritional yeast

Just make a big pot of broth, you can save the rest.

1 Throw the sliced onion in a pan with oil until it becomes translucent. Add a pinch of salt and rice, and stir well for one minute. Add the tomato sauce and paste, and cook for three to four minutes or until the rice absorbs the sauce. Add the wine and cook until it is absorbed. Heat the broth.

2 Slowly add the hot broth with a ladle. Maintain the boil and keep stirring with a wooden spoon. Every time it is absorbed, add some more broth until the rice is ready (about thirty minutes). Add the beans and stir on low heat for two minutes. Sprinkle with nutritional yeast, stir well, and serve.

RISOTTO AI FUNGHI
MUSHROOM RISOTTO

- INGREDIENTS -
1 1/2 cup arborio rice
Vegetable broth as needed
1 small yellow onion
Black pepper
A pinch of salt
A few bay leaves
1 glass dry white wine
1 tbsp margarine
A dash of nutritional yeast
2/3 cups dried porcini mushrooms

1 Soak the mushrooms in hot water for twenty minutes before you start cooking.

2 Slice the onion very thin. Pour olive oil in a pan with a pinch of salt and cook the onion until it becomes translucent. Add the mushrooms and stir for one minute. Stir in the rice for one minute.

3 Add the wine and cook until it is absorbed, then slowly add the hot broth with a ladle. Every time it becomes absorbed, add more broth while stirring with a wooden spoon and maintaining the boil. The rice should be ready within thirty minutes.

4 When the rice is soft and all the water is absorbed, remove it from the heat for few minutes. Put back on low heat, adding 1 tbsp margarine. Sprinkle with nutritional yeast, black pepper to taste, and serve.

RISOTTO ALLA BIRRA CON RADICCHIO E SALSICCIA
BEER RISOTTO with SAUSAGE & RED CHICORY

- INGREDIENTS -
1 1/2 cup arborio rice
1 small yellow onion, thinly sliced
1 tbsp margarine
2 tbsp and 1 tsp extra virgin olive oil
Vegetable broth as needed
3/4 cup beer
1 small red chicory
1/2 cup ground vegan sausage
Nutritional yeast to garnish (optional)

1 Slice the chicory thin. Melt half of the margarine and 2 tbsp oil in a pan, add the onion, and cook on low heat until it becomes translucent. Add the chicory and stir for five minutes. Add the rice, letting it toast for two minutes. Pour in the beer, cook on medium heat until it is absorbed.

2 Start adding the broth, one ladle at time while maintaining the boil until the rice has cooked. While the rice cooks, heat 1 tsp oil in a pan and heat up the sausage, stirring for few minutes on medium heat. Set aside. When the rice is ready, add the sausage and the rest of the margarine. Stir well and serve.

Sprinkle with nutritional yeast for a final touch.

RISOTTO ALLA MILANESE
SAFFRON RISOTTO

- INGREDIENTS -
1 small yellow onion, thinly sliced
1 1/2 cup arborio rice
Vegetable broth as needed
1 glass dry white wine
1 large pinch of saffron
1 tbsp margarine
Nutritional yeast to garnish
Olive oil

For these leftovers, a very typical thing to do in Milan is make "Risotto al salto" (recipe on page 130).

1 Sauté the onion with oil on medium/low heat. Warm up the broth, but keep it from boiling through the entire recipe. Throw the rice in the pan and stir well for one minute. Add the wine and stir on low heat. Add the saffron and slowly add the broth using a ladle.

2 Every time the liquid is absorbed, add more broth while stirring with a wooden spoon and maintaining the boil. The rice should be soft with all the water absorbed within thirty minutes. When the rice is ready, turn off the heat for few minutes. Put back on low heat, add 1 tbsp margarine, sprinkle with nutritional yeast, stir, and serve.

RISOTTO AL MASCARPONE E PEPE ROSA
RISOTTO with MASCARPONE & PINK PEPPER

- INGREDIENTS -
1 1/2 cup arborio rice
Salt as needed
1 tbsp margarine
Vegetable broth as needed
1 tbsp of whole pink peppercorns
1 box of vegan cream cheese
2 tbsp extra virgin olive oil
3/4 small onion, thinly sliced
1/2 cup white wine

1 Heat 2 tbsp of oil in a pan with the onion for few minutes on medium heat. Add the rice and let it toast for one minute while stirring. Add the wine and cook until absorbed. Slowly add the broth using a ladle. Every time the liquid becomes absorbed, add more broth, stirring with a wooden spoon and maintaining the boil.

2 When the rice is almost cooked, stir in the cream cheese. Keep adding broth until the rice is ready. Add the margarine and the peppercorns. Stir well and serve.

RISOTTO AL SALTO
CRUNCHY RISOTTO LEFTOVERS

- INGREDIENTS -
Leftovers of saffron risotto
2 or 3 tbsp of extra virgin olive oil
1 tsp margarine

1 Grease a plate with the margarine. Pour the cold leftovers over and press them with the back of a spoon to make a disc. Heat 2 or 3 tbsp oil in a pan and slide the rice onto it.

2 If the disc crumbles apart, just press it into shape again with the spoon. Let it get crunchy on one side (at least five minutes). To flip the rice with a plate, place a plate over the rice. While pressing down on the plate, flip the pan to drop the rice on the plate, then slide it again into the pan on the other side. Let the other side get crunchy as well, and serve hot.

RISOTTO GRATINATO ALLE VERDURE
OVEN BROILED RICE with VEGGIES

- INGREDIENTS -
1 1/2 cup arborio rice
1/2 medium onion, thinly sliced
1 big carrot, thinly sliced
1 big tomato, diced
1 cup sliced cremini mushrooms
2 cups sliced savoy cabbage
2 or 3 tbsp extra virgin olive oil
1 tsp dried chili pepper
3 tbsp soy sauce
Nutritional yeast to garnish
Salt as needed
Breadcrumbs as needed

You can substitute any of the veggies with your favorites.

1 Heat 2 or 3 tsps of oil in a large pan or wok and cook the onion for few minutes. Add the chili pepper and the carrots and 1 tsp soy sauce and cook for few minutes. Add the cabbage and 1 tbsp soy sauce and cook for a couple more minutes while stirring. Add the mushrooms and stir in 1 more tsp soy sauce.

2 Finally, add the tomato and rest of the soy sauce, stirring well. Lower the heat and cover with a lid until all the vegetables are fully cooked.

3 Boil the rice in salted water. Mix it with the veggies and pour into a greased casserole dish.

4 Sprinkle nutritional yeast and breadcrumbs on top, pour a thread of oil over it, and broil in the oven until you get a golden crust.

RISOTTO ALLE FRAGOLE
STRAWBERRY RISOTTO

- INGREDIENTS -
1 1/2 cup arborio rice
1 small onion, thinly sliced
1 box of strawberries
1 tbsp margarine
1 cup white wine
1/3 cup "panna di soia" **(recipe on page 153)**
A sprinkle of nutritional yeast
Vegetable broth as needed
Salt as needed
Extra virgin olive oil

1 Wash, dry, and slice the strawberries. Set aside a few slices for garnish. Let the rest soak in wine for few hours. Pour oil in a pan and cook the onion until it becomes translucent on medium/low heat.

2 Warm up the broth and keep it at near boiling until the recipe is done. Throw the rice in the pan and stir well for one minute. Add the wine from the strawberries and keep stirring on low heat. Slowly add the broth using a ladle. Every time it absorbs, add more broth and stir with a wooden spoon, maintaining the boil, until the rice is ready. This should take 30 minutes.

3 When the rice is soft and all the water is absorbed, turn off the heat for few minutes and cover it with a lid. Heat the margarine in a pan, toss in the drained strawberries, and cook until it becomes creamy. Add this mixture to the rice and stir well. Add the panna, sprinkle with nutritional yeast, stir well on low heat for one or two minutes, and serve.

RISOTTO UBRIACO
DRUNK RISOTTO

- INGREDIENTS -
3/4 bottle red wine
1 1/2 cup arborio rice
Vegetable broth as needed
1 small onion, thinly sliced
2 branches of fresh rosemary
1 tsp margarine
Black pepper to taste
Salt to taste

Some suggested DIY risotto veggies: asparagus, peppers, artichokes, pumpkin, zucchini and sweet peas, radicchio and walnuts...for hard vegetables such as the pumpkin, you might wanna steam it a little bit before.

1 Toss the sliced onion into a pan with 2-3 tbsp of olive oil. Let it become translucent with a pinch of salt. Add the rosemary, stir, and add the rice. Keep stirring with a wooden spoon and slowly add the wine, little by little as it evaporates.

2 When it is all absorbed, slowly add the hot broth with a ladle until the rice is cooked. This should take thirty minutes. When the rice is soft, remove the pan from heat and add salt and pepper to taste. Take out the rosemary, put the pan back on your stovetop, and keep stirring while cooking after you add the margarine. Stir well and serve.

You can make risotto with any kind of vegetable. Sauté an onion in olive oil and add the chopped vegetables. Add the rice and stir for one minute. Add one glass of white wine and let it evaporate. Slowly add the hot broth with a ladle, stirring constantly with a wooden spoon. When the rice is soft, turn off the heat for a few minutes. Put back on low heat, stir in a little margarine and nutritional yeast, and serve.

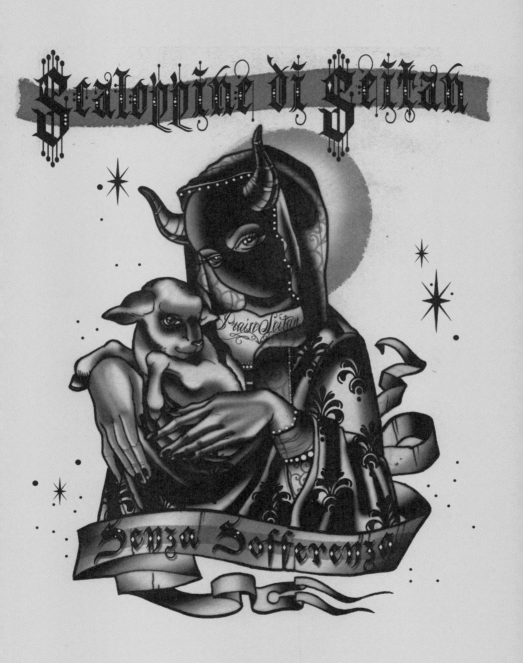

SCALOPPINE DI SEITAN AL LIMONE
SEITAN SCALLOPS in LEMON SAUCE

for two people

- INGREDIENTS -
1/2 inch thick seitan slices
3/4 cups of dry white wine
White flour as needed
The juice of 1 lemon
1 yellow onion, thinly sliced
2 tbsp of extra virgin olive oil

1 Dampen the seitan slices in water and roll in the flour. Repeat this step twice to fully cover them in flour.

2 Cook the onion until translucent in 1 tbsp of oil. Add the seitan and 1 tbsp oil and cook for few minutes. Add the white wine, cooking on medium heat, plus salt to taste, while stirring until it gets absorbed.

3 Add the lemon juice and cook while covered until all the liquid is absorbed. Add a few drops of oil and sauté a little bit more if needed.

Serve with sautéed yellow peppers (see recipe on the next page), a simple salad (arugula matches well), and bread.

PEPERONI GIALLI CON PINOLI E UVETTE
SAUTÉED YELLOW BELL PEPPERS with PINE NUTS & RAISINS

- INGREDIENTS -
2 yellow peppers (1 pepper per person)
1 peeled garlic clove, cut in half
1 tbsp extra virgin olive oil
1 tbsp pine nuts
2 tbsp raisins
A dash of sea salt
2 tsp balsamic vinegar

1 Heat the oil in a pan, add the garlic and the pine nuts and toast on medium heat until they are gold. Cut the peppers, removing the seeds and white part, and stir in with the garlic and pine nuts for five minutes, or until they start browning. Lower the heat, sprinkle with sea salt, and cover with a lid. Let them cook until soft, stirring from time to time. They are ready when they are soft and cooked, but not falling apart.

2 When cooked, stir in the raisins. Remove the lid, turn up the heat, and add the balsamic vinegar. Stir for one more minute and serve.

SCALOPPINE DI SEITAN AL TIMO E CAPPERINI
SEITAN SCALLOPS WITH CAPERS AND THYME

- INGREDIENTS -
1/2 inch thick seitan slices for as many guests as you have
2 small branches of thyme
1 tbsp mustard
2 tbsp small capers
1/2 cup brandy or white wine
2 tbsp margarine
Salt and pepper to taste
White flour as needed

1 *Wet the seitan and roll it in the flour. Repeat twice. Melt 1 tbsp butter in a pan and add the thyme and seitan. Sauté on high heat for about two minutes on each side. Adjust with salt and pepper, and remove from the pan. Set the seitan aside.*

2 *Add the brandy to the butter and thyme and let it almost evaporate. Add the capers and stir for about two minutes. Add 1 tsp margarine and the mustard and stir well to amalgamate with a wooden spoon. Add the rest of the margarine and the seitan and let it cook for one minute on each side. If the flour is still visible, add margarine and keep cooking. Serve with oven roasted cherry tomatoes (recipe on next page).*

POMODORINI AL FORNO
OVEN ROASTED CHERRY TOMATOES

- INGREDIENTS -
Cherry tomatoes as needed
Extra virgin olive oil as needed
A sprinkle of sea salt
Good quality dried oregano as garnish
Breadcrumbs as garnish

1 Slice the tomatoes in half. Oil a casserole dish and arrange the tomatoes with the open half facing up. Sprinkle with salt, oregano and breadcrumbs.

2 Drop a thread of oil over it and bake at 350°F for fifteen to twenty minutes. Broil at the end to make a golden crust.

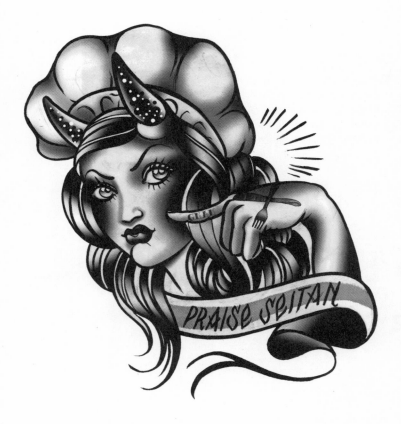

SPEZZATINO CON PATATE
SEITAN STEW with POTATOES

- INGREDIENTS -
Seitan chunks (or mock meat) for two people
1 1/2 big potatoes, cut into chunks
1 small onion, thinly sliced
1 stalk of celery, thinly sliced
1 carrot, thinly sliced
1 1/2 cup tomato sauce
1 tbsp tomato paste
1/2 cup red wine
1 or 2 tbsp extra virgin olive oil
1 branch rosemary

1 Boil the potatoes in salted water until they are "al dente". Drain but save the water. Put aside.

2 Heat 1 or 2 tbsp of oil in a casserole, making a soffritto with the onion, carrot and celery. Add the rosemary. Add the seitan and stir well for couple of minutes on medium heat. Pour the wine and let it get absorbed. Add the tomato sauce, saving 2 tbsp, and paste. Stir well and cook covered on low heat for ten minutes. Add 1 cup of the water from the potatoes, cover again and cook for five to ten minutes, stirring from time to time.

3 Add the potatoes and keep stirring, adding a little more water. Cover and cook. Add the rest of the tomato sauce and stir well for a couple more minutes. If the potatoes are not soft yet, add some water and keep cooking until it is absorbed and they are ready.

SPEZZATINO CON PATATE E PISELLI
SEITAN STEW with POTATOES & SWEET PEAS

- INGREDIENTS -
Seitan chunks (or mock meat) for two people
1 1/2 big potatoes, cut in chunks
1/2 cup dry sweet peas
1 small onion, thinly sliced
1 stalk of celery, thinly sliced
1/2 cup white wine
Extra virgin olive oil
Plain, unsweetened soy milk as needed
1 tbsp margarine
Ground pepper to taste

1 Boil the potatoes and the peas in salted water until they are "al dente". Drain but save the water. Put aside.

2 Heat some oil in a casserole (1 or 2 tbsp), making a soffritto with the onion and celery. Add the seitan and stir well for a couple of minutes on medium heat.

3 Pour the wine and let it get absorbed. Then add milk (about 1 cup), stir well, and cook covered on low heat for about fifteen minutes, adding more milk if needed.

4 Add the potatoes and peas, some more milk (about 1 cup), cover again and cook until it gets absorbed. Stir from time to time. If the potatoes are not soft yet, add some milk and keep cooking until it is all absorbed and they are ready.

5 Add the margarine, stir well for one more minute, adjust with salt and pepper, serve.

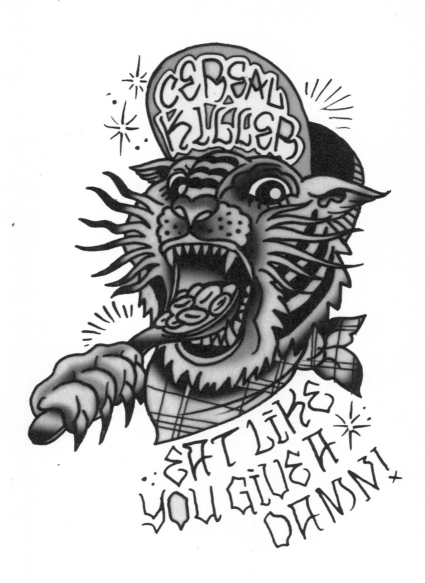

SPEZZATINO CON FUNGHI PORCINI
SEITAN STEW with PORCINI MUSHROOMS

- INGREDIENTS -
Enough chunks of seitan for two people
1 1/3 cup sliced porcini mushrooms
1 small onion, thinly sliced
1 stalk of celery, thinly sliced
1 to 2 tbsp extra virgin olive oil
1 1/2 cup tomato sauce
1 tbsp tomato paste
1/2 cup red wine
White flour as needed
Sea salt to taste

1 Dip the seitan chunks in water and roll them into the flour. Heat the onion and celery in 1 or 2 tbsp of oil in a pan, making a soffritto. Add the seitan and stir well for couple of minutes on medium heat.

2 Pour in the wine and let it get absorbed. Add the mushrooms and sprinkle with salt. Stir well. Add the tomato sauce, tomato paste, and 1 cup of hot water. Stir well and let it cook covered on low heat for about twenty minutes. Stir from time to time.

3 When the mushrooms are cooked and the water is absorbed (add water and keep cooking if the mushrooms are not ready), adjust with salt and pepper and serve.

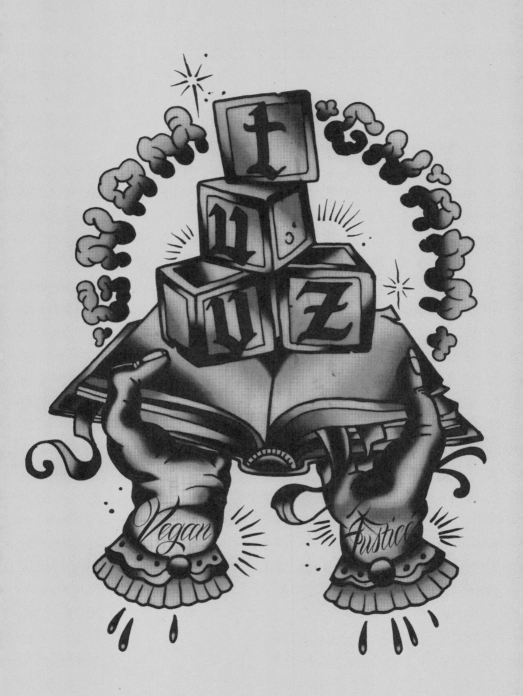

TIRAMISÚ

You can add 1 tsp rum to the coffee.

- INGREDIENTS -

For the chantilly cream:
3/4 cup vanilla soy milk
2 tbsp unbleached flour
1 tbsp cornstarch
2 tbsp margarine
1/4 cup brown sugar
1 tsp turmeric
Zest of 1 lemon
1 1/4 cups vegan whipped cream

For the tiramisú:
Graham crackers, enough to layer your casserole twice
1/3 cup sugared espresso coffee
Cocoa powder as needed for layering

1 In a large bowl mix together the flour, the cornstarch and the turmeric with 1/4 cup soy milk, stirring well.

2 In a small saucepan melt the margarine with 1/2 cup soy milk on low heat. Add the remaining milk, the sugar and the lemon zest. Let it softly boil, mix the previous mixture, and cook for about three minutes. Keep stirring with a whisk. Pour in a bowl and let cool, covering it with saran wrap in direct contact.

3 When cooled, slowly add the whipping cream and stir strongly. Add some water to the coffee, dip the graham crackers in. On a 8" x 12" deep plate, make one layer of crackers, one layer of cream and sprinkle with cocoa powder. Repeat one layer of each. Let it rest in the fridge for about eight hours.

UUUUUUHHHH: LA ROBIOLA VESTITA!
UUUUUUH, THE ROBIOLA CHEESE DRESSED IN RED!

- INGREDIENTS -
1 veg-caprino for each person **(recipe on page 155)**
4 leaves of red chicory per 1 veg-caprino
Sea salt to sprinkle
Black, white, pink, and green pepper
Paprika to sprinkle
Extra virgin olive oil as needed
Pesto to decorate **(recipe on page 107)**

1 Make the veg-caprino very compact (you should place a cheesecloth on a small drainer, wrap the veg-caprino and press well to make a compact shape). Remove from the cloth and drop on a plate. Sprinkle with salt pepper, oil and paprika. Set aside in the fridge.

2 Meanwhile prepare the "dress." Boil some unsalted water and cook the leaves for about two minutes. Drain and wash with cold water to stop the steam. Drain again. Place the four leaves, one across the other to make a sort of flower shape, place the cheese in the middle and close the leaves over it to make a pouch. Warm up a thread of oil in a pan (or a grill), and cook on both sides for few minutes. Serve with a pesto spread on a side.

VIN BRULÉ
HOT MULLED WINE

- INGREDIENTS -
Zest of 1 organic orange
2 sticks cinnamon
8 cloves
Zest of 1 organic lemon
A pinch of nutmeg
1 cup sugar
1 bottle red wine

1 Pour the sugar, the spices and finally the wine into a metal pot. Stir well and slowly bring to boil. Boil on low heat for about five minutes. Carefully flame the surface and let it extinguish by itself. Remove from heat, strain, and serve hot.

This makes an excellent winter drink.

ZUPPA PISANA
VEGETABLE SOUP with BREAD from PISA

for six people

- INGREDIENTS -
1 1/2 cups of cooked white beans
3 or 4 day pieces of stale Italian bread
1 bunch black cabbage, cut into pieces
3 zucchini, cut into pieces
3 peeled carrots, cut into pieces
A mix of sliced onion and sliced celery
Tomato paste
1 red onion
Extra virgin olive oil
Salt and pepper to taste
Vegetable broth if needed

1 Blend 2/3 of the beans in a blender to make a cream. Salt to taste. In a big pan drop some oil and let the onions and celery mix become gold on low heat. Add the black cabbage. Salt and pepper, then add the tomato paste (diluted in some hot water). Add the zucchini and carrots. Cover and keep cooking on low heat for about thirty minutes, continually stirring. Add the creamed beans and the rest of the whole beans, cover again and cook for thirty minutes more. Add a little vegetable broth if needed.

2 In a large casserole, place the slices of old bread on the bottom. Cover with the soup and let it soften a little bit. Make sure you serve at least 1 slice of bread in each bowl. Top with some thin slices of red onion and a thread of extra virgin olive oil. This is also delicious served cold.

VEG-MOZZARELLA

- INGREDIENTS -
2 full tsp potato starch
6 tbsp soy milk
1 tbsp panna di soia **(recipe on next page)**
1 tsp margarine
3 tbsp homemade plain unsweetened soy yogurt
A pinch of salt

1 *Combine the potato starch with the soy milk in a non-sticking pan and let it melt well. Add the panna, margarine and salt. Keep stirring on low heat. When the mixture is getting creamy, remove from heat and add the yogurt. Put back on low heat, mix well and cook until it gets thready (about ten minutes) and starts separating from the borders of the pan.*

2 *Grease an ice cube tray and pour the mixture in (this way you'll get small squares of mozzarella. If you want a solid mozzarella shape, pour in a small greased bowl. Refrigerate for about six hours before using.*

Find recipes online
for soy yogurt!

PANNA DI SOIA
SOY CREAM

 - INGREDIENTS -
I cup plain unsweetened soy milk
I 1/2 cup seed oil (corn, sunflower, etc.)
A very small pinch of salt, only if you plan to make savory dishes

1 Combine the soy milk and salt in a blender. Set the blender on high speed and pour the oil while mixing. When the oil is all gone, keep mixing for a couple more minutes. Voilà!

Advice and clarifications:
You will need a mixer that allows you to pour ingredients from the top because you want the oil to flow in a thread while the blades are moving, so that the panna grows.
If at the end of the operation, the panna is still too liquid, keep mixing for a couple more minutes. If it still doesn't thicken enough, add a little oil and keep mixing.
Remember though, that the freshly made panna is thick but not too compact....you'll need to refrigerate it for at least half an hour to get it perfect.

VEG RICOTTA
VEGAN RICOTTA CHEESE

- INGREDIENTS -
3 1/3 full cups plain unsweetened soy milk
2/3 cup panna di soia **(recipe on previous page)**
A pinch of salt
5 tbsp apple vinegar

1 Bring the soy milk and salt to a boil and then add the vinegar. It will coagulate. Stir well for a little while, add the panna and keep stirring for about thirty seconds. Then drain in a cheese mold. Let it drain very well and then press with a spoon a little to keep it compact. Place over a big glass or bowl where all the liquid can drain out.

2 When it stops dripping (about thirty minutes), remove the glass and refrigerate for one or two days.

3 If you don't have a cheese mold, you can wrap a cheesecloth around the ricotta, tie it to a knife or chopstick and hang it across the borders of a tall glass or blender.

VEG-CAPRINO
VEGAN GOAT CHEESE

- INGREDIENTS -
A little less than 1 cup of homemade plain unsweetened soy yogurt
1 tsp salt or gomasio
1 lemon, squeezed
If you like, you can add any herbs: paprika, oregano, chives, chili pepper...

1 Place a clean cheese cloth on a bowl. Pour the yogurt, close it to make a small bag and tie it to a knife or chopstick, that you will hang across the sides of a tall glass or smoothie processor to drain the extra liquid.

2 Refrigerate one to four days, depending on the consistency you like.

3 Remove the cheese with a spoon and place in a plate, salt to taste and add the lemon juice. Mix and shape as a rounded small cheese. Spice to taste.

VEG-RICOTTA SALATA
VEGAN SALTED RICOTTA CHEESE

- INGREDIENTS -
1 vegan ricotta **(recipe on page 154)**
2 tbsp sea salt

1 Place the ricotta in a bowl, pressing to compact it, then flip it onto a plate. Sprinkle with salt on top and sides. Refrigerate for three more days. Place in the oven at 350°F for thirty minutes. Let it cool and it's ready to be grated or used for other things, including being eaten with bread.

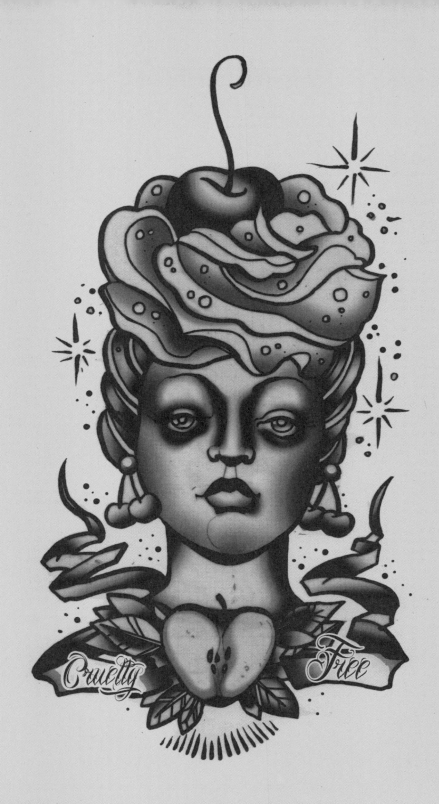

INGREDIENTS INDEX

SUBSCRIBE TO EVERYTHING WE PUBLISH!